Publisher's Acknowledgements
We would like to thank the
following author and publishers for
their kind permission to reprint
texts: **Lewis Baltz**, Paris, **Faber and
Faber Ltd.**, London; **Hamish
Hamilton**, London; and **The
Putnam Publishing Group**, New
York; and the following for lending
reproductions: **Lewis Baltz**, Paris;
Robert Capa/ Magnum Photos,
London; **Fraenkel Gallery**, San
Francisco; **The *Independent***,
London; **Helen Levitt**, New York;
Lawrence Miller Gallery, New York;
Museum of Modern Art, New York;
Maureen Paley/Interim Art,
London; **Pacemaker Press Int.**,
Belfast; **August Sander archive**,
Cologne; **Sonnabend Gallery**, New
York; **Times Newspapers Limited**,
London; **Jeff Wall**, Vancouver; and
the **Estate of Garry Winogrand**,
Los Angeles. Thank you to **Anthony
Reynolds Gallery**, London, and to
Bénédicte Delay, for their
assistance.

Considerable effort has been made
to trace and contact copyright
holders and secure permission prior
to publication. If notified the
publisher will endeavour to correct
any errors or omissions at the
earliest opportunity.

Artist's Acknowledgements
I would like to thank all the people
who have supported the production
of this work over two decades;
space does not permit such a long
list of names, but you know who
you are, and I give my thanks.

I have special gratitude for my
family and friends, who've
tolerated my camerawork so well,
and will have to do so for a while
yet, hopefully.

For this book, the insights of Iwona
Blazwick along with those of Gilda
Williams and Clare Stent helped
smooth out my inexperience with
dealing with so much text. Their
collaboration, along with that of
Stuart Smith and Ruth Müller-
Wirth, was essential in making it
work out. Thanks.

All works are in private collections
unless otherwise stated.

Phaidon Press Limited
Regent's Wharf
All Saints Street
London N1 9PA

First published 1996
© 1996 Phaidon Press Limited
All works of Paul Graham are
© Paul Graham.

ISBN 0 7148 35501

cover, **Untitled, Belfast, 1988
(bricks under skip)** (detail)
1988
Colour photograph
152 × 202 cm

page 4, **Cat Calendar** (detail)
1989
Colour photograph
diptych, right panel 57 × 76 cm

page 6, **Paul Graham**
1988
photo Volker Heinze

page 36, **Army Helicopter and
Observation Post, Border Area,
County Armagh** (detail)
1986
Colour photograph
68 × 87.5 cm

page 104, **Untitled, 1989
(erased Hitler)** (detail)
1989
Colour photograph
triptych, centre panel
152 × 203 cm

page 116, **Girl with White Face**
(detail)
1992
Colour photograph
105 × 80 cm
Collection, Kunstmuseum
Wolfsburg

page 148, **Paul Graham, at home
in Harlow New Town**
1959

page 160, Installations
top row, l. to r., **'Troubled Land'**,
Cornerhouse Arts Centre,
Manchester, 1987; **Equal
Opportunities**, in 'Recent
Histories', Hayward Gallery,
London, 1987; *second row,* **'New
Europe'**, Anthony Reynolds
Gallery, London, 1990; *third row,
l. to r.,* **'On the Edge of Chaos'**,
Louisiana Museum, Humlebaek,
Denmark, 1993; **'New Europe'**,
Fotomuseum Winterthur, 1993;
bottom row, **'Empty Heaven'**,
Kunstmuseum Wolfsburg, 1995

A CIP catalogue record of this
book is available from the British
Library.

Printed in Hong Kong

Andrew Wilson Gillian Wearing Carol Squiers

Paul Graham

Φ

Contents

Contents

Gillian Wearing in conversation with Paul Graham

Gillian Wearing Is there a place to begin?

House Portrait #1
1979
Colour photograph
101 × 76 cm

Paul Graham **I suppose so. I remember 'discovering' photography. I remember clearly, for want of a better term, the light going on. I was 19, and I walked into a magazine store and found** *Creative Camera*, **at that time a very good magazine. I remember the shock of seeing serious photography, it was just a revelation. That was 1976 I think, around there. It's very strange when you feel an immediate empathy for something. You just feel you've utterly understood it, that it resonates inside you. I still get that feeling today when I see really good work.**

Wearing What issues were you hoping to see with photography?

Graham **If I'm honest, I guess the biggest issue at that point was finding my own voice. Trying to express this profound empathy that I felt for the medium, seeing, if you like, that as well as going into me, that it could come out of me.**

Wearing It was slightly different for me when I chose photography, that's why I asked that question. I had an idea, and photography was the way of working out that idea.

Graham **I suppose you could say that I had a hunger for an expressive outlet, and photography was a way of answering that hunger.**

Wearing How did that relationship develop?

Graham **It developed through seeing good work. A friend sent me a catalogue for a body of colour photographs called** *Election Eve*, **by William Eggleston. It was a really thin pamphlet with just four photos, and it blew me away. He is often-cited for his show at the Museum of Modern Art, New York, but to be truthful, I didn't like that so much. The book,** *William Eggleston's Guide*, **was not as powerful for me as this smaller catalogue. It wasn't only the photographs, you see, it was the structure of the project – to travel from his home town to Jimmy Carter's home town over the month leading up to the presidential election, and photograph the state of the nation. It was so elliptical, so tangential to traditional photographic practice that that approach probably moved me more than any specific image.**

Wearing I can see that; I can draw parallels.

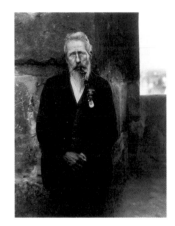

above, top, **August Sander**
The Master Tiler
1930
Black and white photograph

above, **Walker Evans**
Moundville, Alabama
1936
Black and white photograph

Graham **Yeah, and it's good to be honest about it. It was quite influential for a while but then I reacted against it, drawing upon the work of people like Walker Evans, August Sander and the 'New Topographics' work. I went to the opposite extreme and made the** *House Portraits*, **which were just the fronts or sides of houses. They were incredibly austere. I used to get up at three a.m. to go and catch dawn in these modern housing estates when the light was really strong . I got completely immersed in that, probably because I was brought up in a new-town and it struck a particular chord. I did that for over a year, then thought, right, now I'm free. It's quite strange, I felt like I'd learnt something fundamental.**

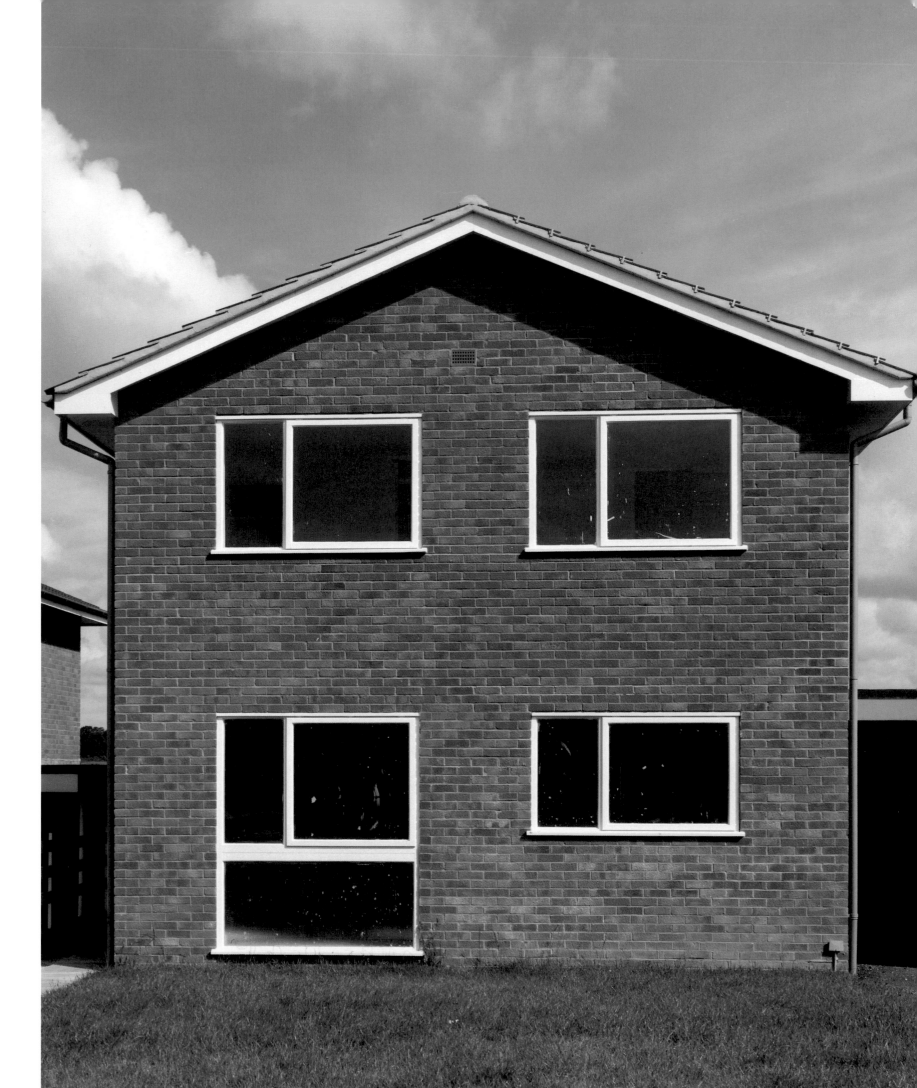

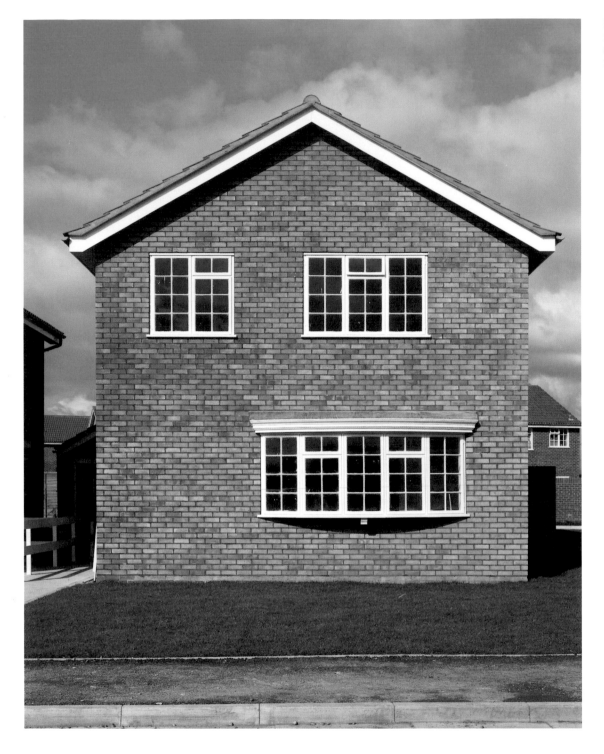

House Portrait #3
1979
Colour photograph
101 × 76 cm

Houses Portrait #10
1979
Colour photograph
76 × 101 cm

Wearing You'd gotten your own voice?

Graham I'm not sure if I would go so far as to claim that at that point, but I certainly felt a clear change. You know, when you look back and somehow see everything in perspective, catching yourself in the rearview mirror as it were? Recently I realized that the work I'd made in my 20s – that's *A1, Beyond Caring* and *Troubled Land* – were different and distinct from that made in my 30s – *New Europe, In Umbra Res* and *Empty Heaven*. The earlier work was produced with the consciousness of the outside world being there, waiting to be photographed, and me positioning myself against that. Later the world was more useful as a source for reflecting essentially invisible concerns.

Wearing I understand, especially in the beginning where you position yourself in your surroundings. I can relate to that because that's how I felt when I started out in my relationship to other people.

Graham **Do you think that's always necessary? Do you think that artists have to orientate themselves to the outside world first?**

Wearing I don't think it's necessary, no one ever told me to do that. I was particularly interested in documentaries, not accepting any handed-down truths, finding out what my relationship is to things, my own truths. I think those areas are quite important because then you can see there are actually other ways of dealing with it. Photography still talks about the world, the truth comes into it somewhere along the line.

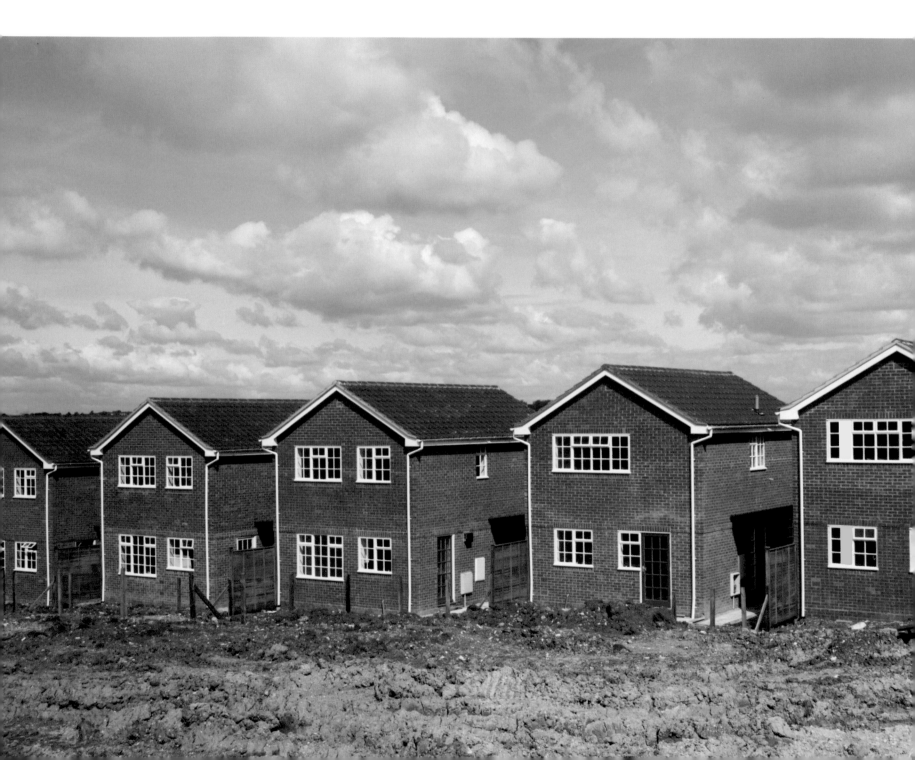

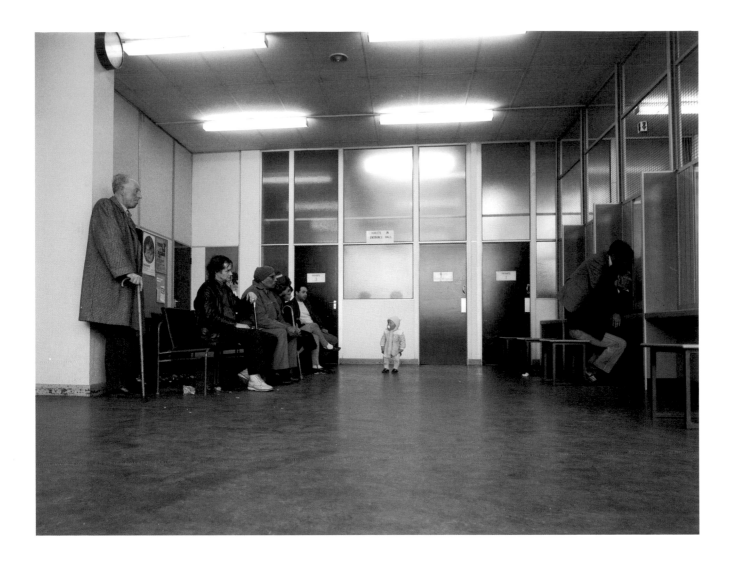

Baby, DHSS Office, Birmingham
1980
Colour photograph
68 × 87.5 cm
Collection, Arts Council of Great
Britain, London

Graham **You know how at certain ages you're fighting angry about certain issues?** *Beyond Caring* **was fighting talk, in a way, confronting the economic violence being done to a large section of the population by early 1980s Thatcherism. It wasn't some theoretical principle, it was my personal situation. I was unemployed, so giros, UB40s, waiting rooms and endless interviews were a part of my life. What is interesting about these places is that they are where political policy and people collide, where economic decisions and human lives meet head on. This was the primary concern of the work . The other factor, and remember this was 1984, was that people were shocked to see work like this made in colour; 'serious' photographers used black and white and that was that. Colour was seen as trivial, and it's hard now to imagine the flack it received, people thought I was taking a serious subject and trivializing it, as if colour film removed any social context.**

Wearing Whose noses was it getting up?

Graham **I guess we're talking about the photographic establishment. Some people embraced it and saw it as something positive, but other people – Magnum photographers, photojournalists – would pick on this photograph for example, the baby in a waiting room in Birmingham, and say that any social interpretation is undermined by the fact that the child is wearing pink, and that's a happy colour, so surely it would be better in black and white ...**

Robert Capa
Near Cerro Muriano
(Cordoba front)
5th September 1936
1936
Black and white photograph

Doorway, Dole Office,
Hammersmith, West London
1984
Colour photograph
68 × 87.5 cm

Wearing But colour work did have a context of its own at that time.

Graham **True, and again these images worked a bit outside of that colour genre, as it was then. They were non-colour images, with fluorescent light casts, dull institutional colour schemes, grey corridors. The few bright colours are those of forcefully optimistic orange seats or yellow walls.**

Wearing Do you ever feel that you were coming from the photojournalism angle, or did you always consider yourself separate from that?

Graham **I never considered myself a photojournalist. I considered myself a photographer, I suppose, but labels only confused the issue.**

Wearing Right, but you can see that there's a barrier between yourself and that trade. I wondered if that extends into the work you did in Northern Ireland, *Troubled Land*.

Graham **I suppose it did, because that work transgressed two genres, mixing up landscape and war photography, and remember that war photography is the hallowed, high ground of photojournalism. To many people that was plainly perverse, to go to a war zone and make landscape photography, but I think that it was in part a reflection of my distance, and a way of approaching something big and beyond ordinary rational comprehension, starting at arms length, as it were.**

Wearing Yeah, and it has a British reserve.

Graham **Sure, it's strange how work always ends up having a degree of self-reflection in it no matter what you do. A key image that helped me locate the work was *Roundabout, Andersonstown, Belfast,* 1984, where you simply see a scruffy suburban fringe of Belfast, with everything looking quite banal, at least to anyone familiar with the topology of the British Isles, but then you realize all the lights have been smashed off the stands, the posters are placed very high so that nobody can interfere with them, the roundabout's all ripped up, there's nationalist graffiti on the railings. And then finally you see the soldiers, one running over the roundabout, others walking away on the extreme right, secreted into this everyday scene. So the inventory isn't actually correct, what appears to be ordinary is quite extraordinary, and perhaps more interestingly the opposite is also true, the adoption of the extraordinary into the ordinary fabric of the place.**

Wearing What problems would this cause for photojournalists?

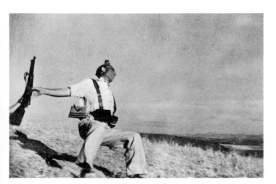

Graham **These images are the reverse of press photographs. Photojournalists always use Robert Capa's famous dictum, 'If your pictures weren't good enough you weren't close enough'. You are supposed to be there, running with the soldier on the front line. Through these images I realized that you can reverse that; instead of running with the soldier you can pull back to show the surroundings. Instead of isolating a detail, like the soldier, you can reverse out of that to embrace the housing estate, people going shopping, graffiti, the gardens, paint flecks and so forth.**

**Waiting Room, Southwark DHSS,
South London**
1984
Colour photograph
68 × 87.5 cm
Collection, Musée de la
Photographie, Charleroi, Belgium

Wearing The first time I ever saw that the houses were painted in Northern Ireland was when someone went on holiday there and brought back photos. What were your own thoughts on Northern Ireland, what was going through your mind when you were there?

> **Graham** I guess, without trying to be slippery, that was the question for me as well. That's probably why I was there. It's part of our country, rightly or wrongly, and I wanted to find out what was happening in our name and how it differed from what the newspapers told you.

Wearing Did you reach any conclusions?

> **Graham** Art isn't about providing answers, is it? It's more about questions – asking thought-provoking, unexpected, unarticulated questions.

Wearing Did it change your mind in any way, because, I mean, war's always about land, isn't it? It's funny how we often see images of people when we know it's actually about soil. We are told about human suffering in isolation, even though it's a consequence of disputed territory.

> **Graham** For sure, the land is an issue at the heart of this dispute: who has the rights to it, whose history is contained in that soil. What I overlooked at first, but which became extremely important to me later, was how the reality out there completely changes according to one's polarized perspective of it. There's this territory in Northern Ireland, and some people were seeing it as Irish and claiming it as theirs, and trying to alter it to match their reality, painting kerbs, putting up flags, graffiti, and yet other people were seeing it completely from another perspective, another reality, according to where they came from. It's such a simple thing, but you just have to have it driven into yourself, that the world out there alters completely according to the way you look at it. It's the same bit of land, but people have their own versions of it in their minds, and were trying to impose that over and above others. That was a hard, useful lesson, and it made a big change possible in my work – recognizing that you had to consider the fractured nature of reality, the invisible, personal nature of it. That made me reconsider my approach to photography – how much of our world you can see and photograph.

Wearing It's interesting how, when you find a structure to explore, you go there with certain notions but enter a state where you forget that knowledge and see beyond it to something further, unexpected.

> **Graham** Sure, that's why we do it isn't it? Forget the popular, clichéd misunderstandings of artists' motivations. One real reason is to go beyond your knowledge, to transcend that foreground and be seduced by your own actions into unpacking something unexpected yet insightful and fulfilling.

Wearing How do you enter that state?

> **Graham** I guess I just work my way through my limited knowledge and out the other side. I photographed in Northern Ireland for many weeks, but all the early images were rubbish, and I was lost till I found the roundabout image. I

Unionist Coloured Kerbstones at Dusk, Near Omagh
1985
Colour photograph
68 × 87.5 cm
Collections, Metropolitan Museum of Art, New York; Wolverhampton Museum and Art Gallery

Republican Coloured Kerbstones, Curmin Road, Belfast
1984
Colour photograph
68 × 87.5 cm
Collection, British Council, London

Roundabout, Andersonstown, Belfast
1984
Colour photograph
68 × 87.5 cm
Collections, British Council,
London; Det Kongelige Bibliotek,
Copenhagen; Wolverhampton
Museum and Art Gallery; Victoria
and Albert Museum, London

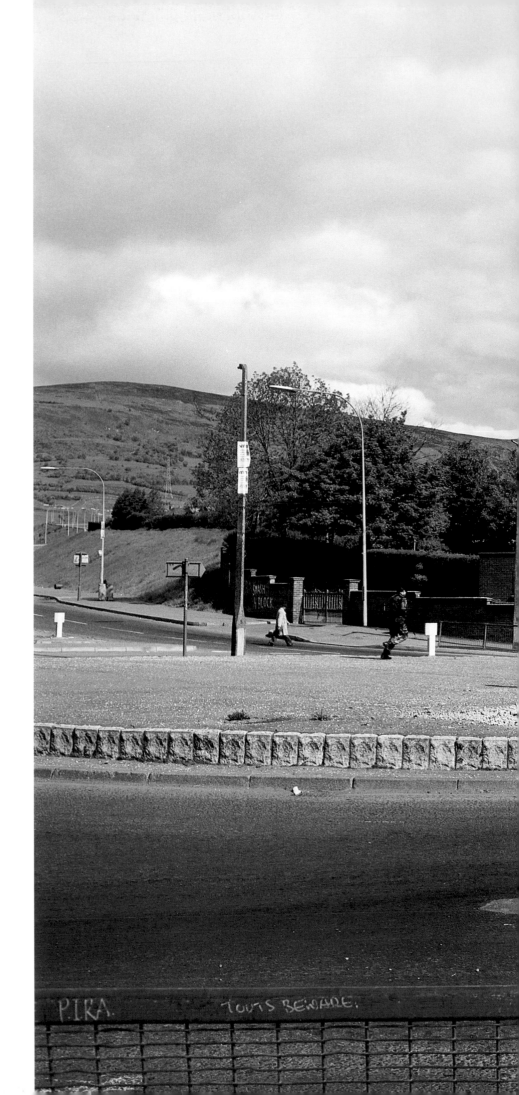

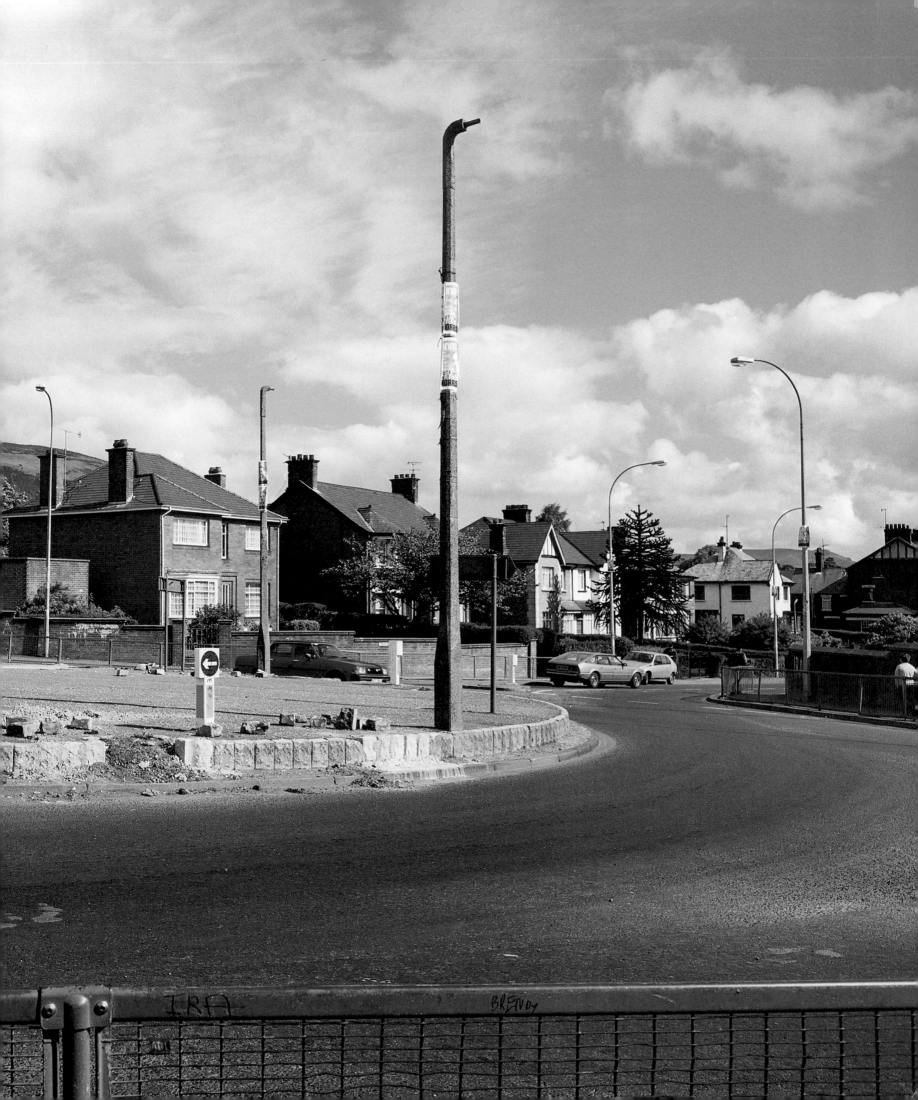

Untitled, 1988-89 (one armed
man; window reflection)
1988-89
Colour photograph
diptych, 75 × 100 cm each

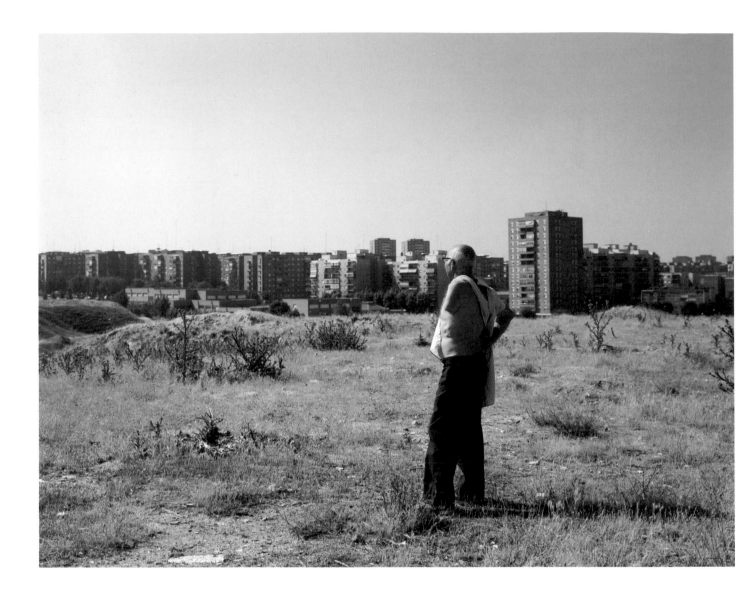

took that photograph without much thought, so you could call it an accident,
but then I subscribe to that school of thought which says that you should
look at your mistakes and accidents as your subconscious strategies.

Wearing When I go back to some of my sign photographs, the ones that I've
never shown, I think, God, they're actually quite amazing, but I just ignored
them at the time. You have to keep on going back to realize that there are other
nuances there that may be more relevant to what's going on in society. That's
one of the wonderful things about photography, that you can keep on going
back to what you're showing and find new readings.

Graham **Sure, as your perspective changes, what was opaque at the time
becomes clearer. The medium has this amazing consultability that extends
far beyond the surface of the image.**

Wearing But surely when you combine photographs in diptychs and triptychs,
as you do, you close some of those avenues.

Graham **That's always the problem of putting work together, which pho-
tographs you combine. Whether it's just in the sequence of a book or**

exhibition, or locked into the diptychs and triptychs, you're trying to tease out certain readings yet not deny other positions, not trap and kill the work. It's a fine balance. Gombrich, writing about Picasso, talks about how if you explore his symbols and metaphors of sexuality, life, fertility, etc, although these are all there, to actually give every symbol a name, to declare it, is to deny it its secret integrity, and destroy it.

Wearing Which brings me to the first photograph in *New Europe*, the guy with the war wound. It looks like he's mourning some kind of a loss; when I first saw it I was thinking maybe that area might have been bombed and replaced by new housing.

Graham **Well, yes, it's a photograph of a man with an amputated arm, looking across the new developments on the outskirts of Madrid, although it could be almost any modern city.**

Wearing But I know there's more to the image than that.

Graham **Indeed, it's a gay cruising area, and he's out offering himself, his body, for what it is – the seductiveness of the wounded flesh. That's why it's**

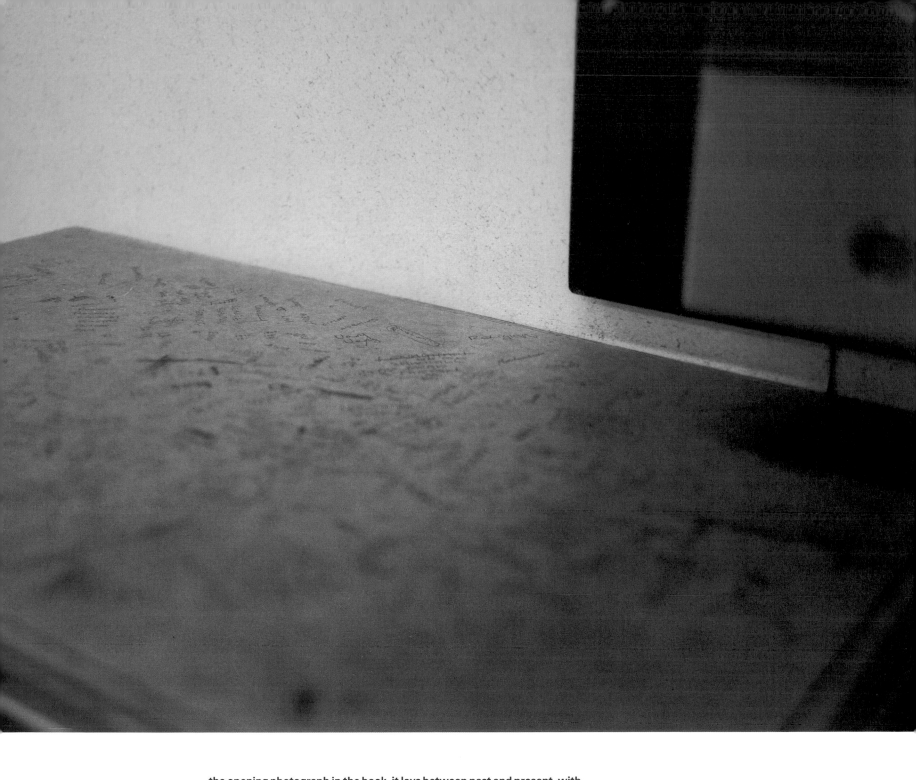

the opening photograph in the book, it lays between past and present, with damaged lives connecting them. I put that with an image of a very barren barber's shop, also in Spain, with these sparkling chandeliers reflected in its windows. They're probably just paste, an illusion of wealth, floating there out of reach. I use the two as a diptych on the wall or sequentially in the book, and, this is difficult, because I'm close to doing what I was referring to with Gombrich just now. I guess it's largely subliminal, that connection where both touch upon something that's not there anymore – the wealth in the window is illusory, and they say that you still get feelings from a lost limb. So it's about sensations from an amputated past. There you are, I've killed it now, explained it away. I've pinned the butterfly down!

Wearing But that is an interesting area, what we want to hear, what we want explained. It's a bit like that in the cinema when there's a narrative that's not

giving the full picture. We're always looking for the story aren't we?

Graham **Yes, looking to understand, for answers that make sense. Like we said before, I'm happy to have found interesting questions, perhaps unanswerable ones. Photography is well-suited to this, to pinning fleeting moments down, piercing the opaque membrane that surrounds us. The problem is how to select that sliver, that thousandth of a second that is meaningful, out of the whole. Which stones will keep their colour once they've been pulled from the river? Sometimes they're just made on a hint of a feeling, an intuitive whim, and one can't rationalize it till later.**

Wearing The photographs in *New Europe* from Northern Ireland are quite different from the earlier ones.

Graham **Sure, physically they're a lot closer, more direct and visceral. The photograph taken in an unemployment centre in Belfast shows just a scrappy corner of the phone table, where people ring up after jobs, and looks across the tabletop full of graffiti to touch on the word 'religion' which someone has scribbled there. This is obviously because they were asked, or were worried that they'd be asked, are you Protestant or Catholic? The wire on the post**

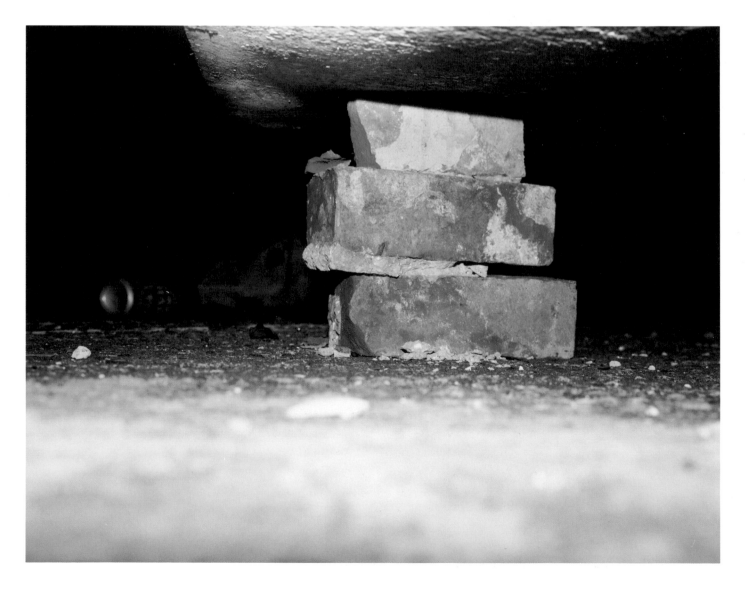

image was something I'd seen and went back to photograph at night because I wanted it surrounded by blackness. I mean, it's just this house post on the one hand, quite ordinary, but then again, with its crown of thorns, its wounded side, it is much more about the pressure of being there, the crucifying psychological burden.

Wearing You're putting these disparate elements together, but they all have a relationship, in some way, if you start looking closely.

Graham **When I was making this body of work it was one of the most traumatic, intense periods for Northern Ireland. They were burying the people that were killed by the SAS in Gibraltar, and then a gunman attacked that funeral and killed some of the mourners. Then at the funeral for those mourners they caught two soldiers in a car, and they were lynched on the spot. It was an endless black spiral. Looking back I would say that you enter this state of numb hypersensitivity. It's hard to name it but, for example, even late at night, when you're eating your take-out dinner at the side of the road, you look at this skip behind you and realize that someone's shoved three bricks under the corner, and they're completely crumbling, disintegrating from the weight of the load, because they're being asked to bear too much. It's some sort of transcendent frame of mind you enter, quite impossible to describe.**

Wearing Was it an intense time, going around Europe when you did all the photographs for *New Europe*?

Graham **Going and coming. I had to get the tourist out of my system; you have to get the sightseeing out of the way, then get angry and frustrated with yourself. Photographs are everywhere and nowhere. You can go around the city all day fruitlessly, then you might be sitting at the bar late at night, only to find yourself opposite this guy who had come from East Germany, and he's sitting in a disco, surrounded by colourful lights, the appealing glow of entrancing promises ...**

Wearing That one's out of focus. I don't know if that's deliberate ...

Graham **Oh is it? I've never noticed that! But surely a photograph can never really be out of focus, if that is how you experienced it? It took me some time to relax about those sort of things. I am very jealous of people who come from an art background and don't give a toss about technique. I remember when you exhibited your photographs at Interim Art, you had rather badly-made big prints on the wall, from Snappy Snaps or somewhere, and I offered to print them better for you, sharper prints and so forth, only for you to say, 'Mm, thanks', pretty non-committal. So I walked around and thought, why was she so uninterested? Then I suddenly realized that you wanted them like that, you were happy with the feeling of them, and it didn't matter if the edges fell off out of focus or whatever ... The light went on, and I thought, why not? It's liberating when you realize that you don't have to have high production values, as long as the feeling you want is in there.**

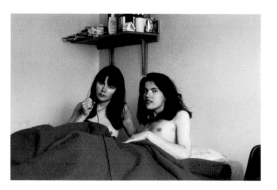

Gillian Wearing
Take Your Top Off
1993
Cibachrome print mounted on
aluminium
74 × 99 cm

Wearing And also you can evoke memories of the way people take photos anyway.

Graham **Sure, break down those barriers.**

Wearing Actually our relationship with photographs in everyday situations is a physical one, when we get our holiday snaps we hold them. Sometimes framing can get in the way of what we feel, we can't get near it. Glass can distort when you want to look at it directly.

Graham **I tried hard to get the photographs out of frames or out of that whole acid-free archival mounts business, but you're still left with an image on a gallery wall, which is slightly unnatural. That's one reason why books are important to me, that intimacy.**

Wearing Sure, and you could never hold a big photograph anyway! But whilst we've talked about individual pieces, we've been skating over the issues of the work as a whole. Obviously history's very important to you; it seems to be an undercurrent in a lot of the recent work.

Graham **When I started that work it was just on the feeling that this was a significant time for Western Europe. Only after I had gone some way down the road did all this stuff about 1992 come up. Prior to that nobody was talking about the single market, European unity, economic and legal bonds, etc. Then suddenly there were all these promises of a new beginning, facing the future hand in hand, free from the shackles of the past ... and I'm sorry, but one should always be sceptical of promises of new utopias. Spain's not going to forget about Franco, his shadow is stained into the place for a long time yet. You realize this history is not something dead and buried, it pursues people in every country.**

Wearing It seems to be becoming more apparent now since Bosnia. Nationalism is hitting back quite hard when we didn't expect it.

Graham **There's a village in Bosnia where people live together in a mixed, intermarried community, and when the war started they regarded it as something far away, on the other side of the country. A few months passed by and it was only 20 miles away; a few weeks later and it was in the next valley. Then suddenly one morning a car drew up in the centre of their town, out got some young men who went to a particular house, knocked on a certain door, and shot the boy who answered dead. Then they got back in their car and drove away. All the younger people were devastated by what they saw as a senseless attack, but the older people understood, they knew that the dead boy's father's father had killed someone 50 years ago, just after the Second World War, and that this very specific murder was the settling of a score that had been simmering for 50 years.**

Wearing That's very dramatic. It's not as obvious in Britain, it's more nebulous than that isn't it?

Graham **Sure, but we're continually living in our past. I remember this taxi driver saying how when he drives through the East End of London he feels like shouting out to people on the streets: 'The war's over ... you can eat good food now! Buy fresh vegetables, there's no more rationing, enjoy life!' You do**

almost have to shout at people to get them out of this historical torpor.

Wearing I'm quite interested in how we address all this. It's a very ambitious thing, isn't it, to address that 'new Europe' …

Graham **It's an ironic title, obviously.**

Wearing Yeah, sure, but it's still ambitious, on whatever level you look at it.

Graham **Of course it's ridiculous if you try to address everything, but you can narrow it down to a couple of main concerns, like how the past pursues each nation state, Germany, Spain, Ireland, Italy and so on. The other interesting question for me was what are we heading towards, what is this united common goal? Is the prospect simply a capitalist consumer heaven that they'd have us accept? If you're too poor to take part, or your lifestyle's too different, are you to be marginalized? I wanted to make pictures about the banality of this promise, of people caught in a modernist nightmare, trapped in this web of consumerism with all its promises. Didn't you feel that personally? I spent all my Saturdays going to shops; that's what you did when you were younger, and you finally realize that it amounts to nothing. You realize how hollow it all is.**

Wearing I've been trying to escape Sundays most of my life! But mostly I've been trying to escape boredom.

Graham **It's this dead avenue of existence, that's why I put the shoppers' photograph next to the image of a false wall. I don't know if this will sound pompous, but *New Europe* was quite different from the previous works. As a book it did strive for something denser, layered, requiring multiple readings, to work as photographic 'literature', if you can call it that.**

Wearing I think I prefer images which start having intimate associations on the wall or page.

Graham **At the beginning I never realized that you could do that. You're brought up to believe photography works on the surface.**

Wearing It's hard to break away from conventions, isn't it? And once you've been in it for a while, you have to keep on trying to question yourself.

Graham **I could have had a very successful career making more *Troubled Land*-style photographs, but can you imagine a fate worse than being trapped into repeating your own successes?**

Wearing People remember what you were doing when you were first discovered.

Graham **Keeping that excitement takes real determination. So much baggage accumulates around your imagination that you can become leaden, grey. Without the energy to interrogate yourself you're dead. For example, going back to this question of history, I began asking myself, what was at the heart of this? Somewhere in there is the question of what kind of pressure a**

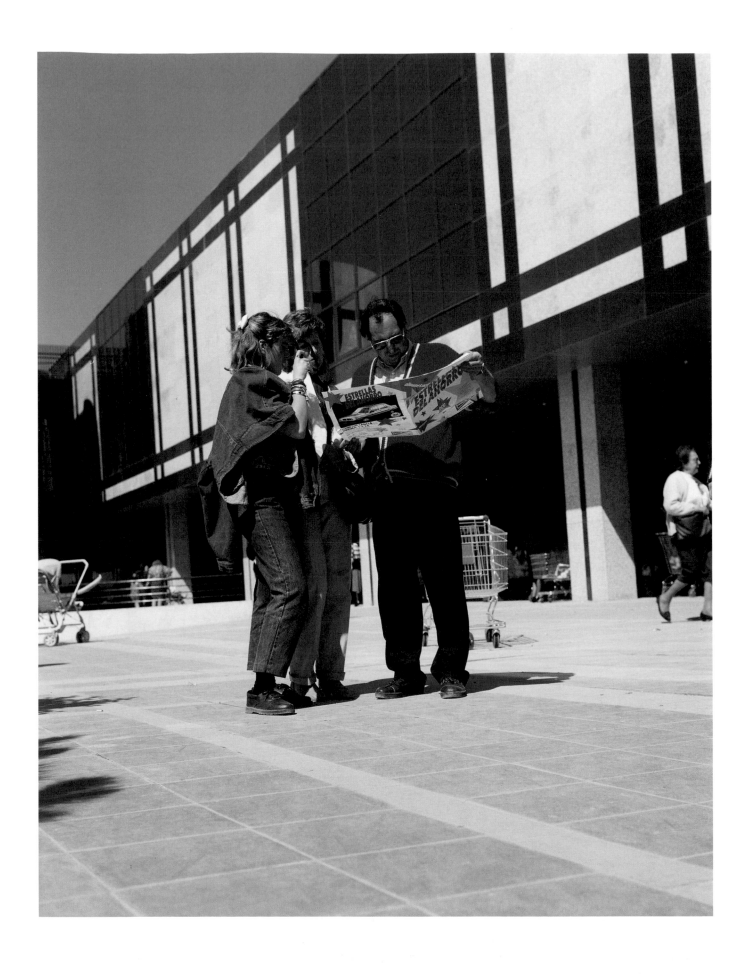

society, and ultimately individuals, hold within them, bottle up inside their heads. What containments do we live with?

Wearing Whether we share identities or not.

> Graham **Everyone has these burdens within them, and I guess that's really what interested me, the balance between living a normal life and these unspoken weights that have to be carried, sometimes passed down through generations, often unwanted, on the shoulders of people across a nation or continent, concealed, hidden. I realized that concealment is something important that has run through a lot of my work, from the landscape of Northern Ireland, and the unemployed tucked away in backstreet offices, to the burdens of history swept under the carpet in Europe or Japan. Concealment of our turmoil from others, from ourselves even.**

Wearing How do you feel you can gain insight into that?

> Graham **It's difficult for me to answer that. I don't know if I want to talk about this really, but I had a bad past when I was younger. I went to a tough school in a newtown, and there was a lot of pressure – physical, psychological, intimidatory, some real, some in the mind. I had to take tranquillizers for a time, and I think that experience made me very aware of the stress and turmoil that people can hold within them, under the surface. It was a very formative thing, understanding what people can conceal within themselves – and from themselves, when it becomes too painful – yet maintain outwardly normal appearances.**

Wearing People modify, they try to fit in. This obviously connects to the Japanese work.

> Graham **Sure; what is the burden of being Japanese? It's an interesting question, as they've dealt with the past quite differently, and, for the majority of the population, quite effectively. The work centred on that gap between the past and the blanket of willed happiness, pink-out culture, that smothers everything; the masks of happiness and benevolence that cover history and power structures, invisible yet all-embracing.**

Wearing Japan is still very isolated as far as cultural gaps are concerned. I did a piece with a camcorder where I went round and asked Japanese people why they liked London so much …

> Graham **I didn't know that. What did they say?**

Wearing They tried to be polite on the whole, and said they liked it because of the shops – they go to Scotch House and buy labels that are very British – Burberry, Aquascutum, etc. I kind of touched on it very lightly, but you still feel the same kind of distance; I felt that I hadn't got any closer. You actually told me before that you think there's a lot of similarities there.

> Graham **Human beings aren't so very different.**

Preserved Keloid (Radiation) Scars, Hiroshima; Butterfly, Tokyo
1990
Colour photograph
diptych, 76 × 57 cm each
Collection, Kunstmuseum Wolfsburg

Wearing I don't mean alien, but culturally there are gaps.

Graham **Yeah, sure. But you have to resolve it down from that to how the social structures affect people.**

Wearing The close-ups of the men you did are very much like some of the images that I did do with the camcorder.

Graham **Oh really? So did you ask men as well as women?**

Wearing Most of them were women, but I did ask men. With the men for some reason I just went quite close up to their faces, and I don't know what the connection is there.

Graham **You'll have to show me this!**

Wearing I've wiped a lot of it off, because I wanted to use the hi-8 tape for something else.

Graham **It's a great pity you can't wipe some photographic films out again. In *Empty Heaven* I found myself sometimes re-photographing a photograph, because if you're trying to seek out sources of experience, then sometimes key images become icons of that event: the atomic fireball, or the moment of surrender. The actual photograph becomes a source of experience in its own right, a touchstone. That validated them as subject matter for the work. I'm explaining this because normally I had a problem with such ways of working – I guess it's part of the baggage I carry.**

Wearing I think you can't escape a sort of baggage, personal and artistic.

Graham **I also used to be sceptical of artists who travelled to make their work, and I'm very conscious that my work could look like that, but it wasn't. I didn't plan to go to Japan, I just stumbled into it. That's kind of why I did the *Television Portraits*; they were the antithesis of working in foreign lands: taking photographs in your own home.**

Wearing Is that how you thought of it? You sound so self-deprecating.

Graham **Perhaps you're right, that's too neat. No, I was with my flatmate watching television, and just took this picture, *Cathy*, and realized how beautiful it was.**

Wearing How many are in that series?

Graham **It's open-ended. I keep doing it. Funny thing is I can't set them up. I'd like to have about 20 of these, and I've got 12 now, but it never works when I say, can I come round to your house and do one of you? I tried it, and it just doesn't work.**

Wearing Strange, because there are some times where I have to be careful with the timing, and in that kind of situation there's this kind of intuitive quality when you know it's going to be right.

Graham **But you must set up such situations, when you were doing *Dancing in Peckham*, for example.**

Wearing I had to, but I knew that would be easier because I was relying on myself. It's when I rely on other people that it's very difficult, because I'm depending on their collusion.

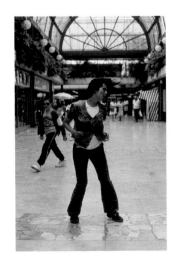

Graham **But then I have the collusion of the world to my ideas. I come along with a set of ideas about Japan, for example, and then see how much the world colludes with those ideas and thoughts. You start out with a structure, and as long as it's not dogmatic, when ideology overrules the subject, then you discover more than your ideas could ever hold. That's the great thing about photography – it's so close to life. Have you ever rejected people's collusion only to come back around to them later?**

Wearing The problem for people seeing photography as art is that it's one, single mechanical action, rather than something constructed over a great space

of time, as in painting or sculpture. Perhaps an exception is when people digitize their images, composing and manipulating in the computer and studio, but the majority of work falls outside that, and that's where the problems lie.

Graham **That's right. By all the traditional measures with which one judges the craftsmanship of the artist, photography fails to deliver because of its mechanical nature. I remember reading the first photography review in the *Independent*, and the opening line was, 'Photography is a fundamentally repellent medium'. I was amazed at this, but I guess I shouldn't have been, because it reflects the prevailing misunderstanding about artistic practice residing in craftsmanship. The mechanical quality of photography, considered a limitation, is precisely its strength. Most contemporary art strives to move towards some kind of quasi-mechanical mode of production, and photography is already there.**

Wearing You could argue that it was the first modern art movement; it certainly changed the way painters looked at the world.

Graham **Oh sure, it liberated painting, but going on from that mechanical aspect, there is a difficulty of attribution, because when you take a photograph you basically buy everything in a job lot, don't you? I could take a photograph of you now, but I'm also getting the bowl behind you, the mirror, and the scene out the window.**

Wearing It seems you only control a tiny bit of it.

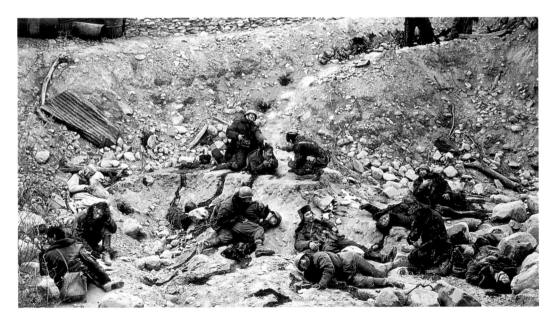

Jeff Wall
Dead Troops Talk (A Vision after
an Ambush of a Red Army Patrol,
near Moqor, Afghanistan, Winter
1986)
1992
Cibachrome transparency on
lightbox
229 × 417 cm

Graham **Yes, so how can you tell what was intended? Work like Jeff Wall's is obviously less problematic, because it's completely controlled and then digitally re-engineered afterwards. People have proof that every square millimetre of the image has been planned, even though the end product is exactly the same: a big colour photograph on the wall. When you go out there, look at something and say 'this is right', these hoary old problems of attribution, mechanization and artistic control emerge. When I first showed**

Troubled Land in France in 1987, I had some guy asking me how long it had taken to paint the kerbstones, and what a good climber I must be to get that flag high in the tree! He thought I was a landscape intervention artist, and this was the documentation of my works. He was disappointed to realize that I 'just' take the pictures.

Wearing Do you think it's changing? Is it becoming acceptable? Do younger artists have an easier time than you had?

Graham **Of course, and I had an easier time than photo-artists before me, and I acknowledge all the groundwork those people – the artists, publishers, the people at The Photographers' Gallery – have done. If it weren't for them fighting their corner at that time, not as much would have been possible now. But the demarcations are coming down even now, which are all for the better.**

Wearing What about the demarcation between photography and video? I was going to carry on using photography, but I pursued video in the end. Although video's got its limitations, it loses something photography has, which is so beautiful, about a moment, the way it fixes everything as all-important.

Graham **Against that there's what Wittgenstein called the 'fascism of the snap decision', clicking your fingers, summing up the world in an instant. It's so arrogant. That's why so many photographers work in extended series of 30, 50 or more photographs, to deflate that quality.**

Wearing Are there any younger photographers around whom you're interested in?

Graham **Of course! But to be honest I'm more interested in the contemporary art world right now, which includes photographic work. Probably what I'm looking for, selfishly, is to broaden my own horizons, escaping from the shackles of the photographic ghetto. I may have broken the chains, but they're still sort of rattling around my ankles!**

Wearing But the work has changed over the years, you're isolating people and objects more. Before the photographs were broader, all-inclusive.

Graham **My gallerist asked me why I always put things in the centre of the photograph, which sounds like an embarrassing or critical question, but then if this is what you want to photograph – this person, this object – then why not put them in the centre? You really don't need to play clever games, or resort to any of that graphic design artistry. If that's what is interesting, let it sit there, right in the middle of the picture, be it the cancelled Star of David, the bloodstain remover or the Japanese boy. Show it plainly and clearly; no clever lighting, avoid all that stuff of being a great photographer. That's enough if something profound lays beneath the surface of what's being photographed; you only confuse it by adding decorative flourishes on top. That's not creativity, that's stylization.**

Wearing No, but beyond the photographic, there have been points of constancy and points of change in your work.

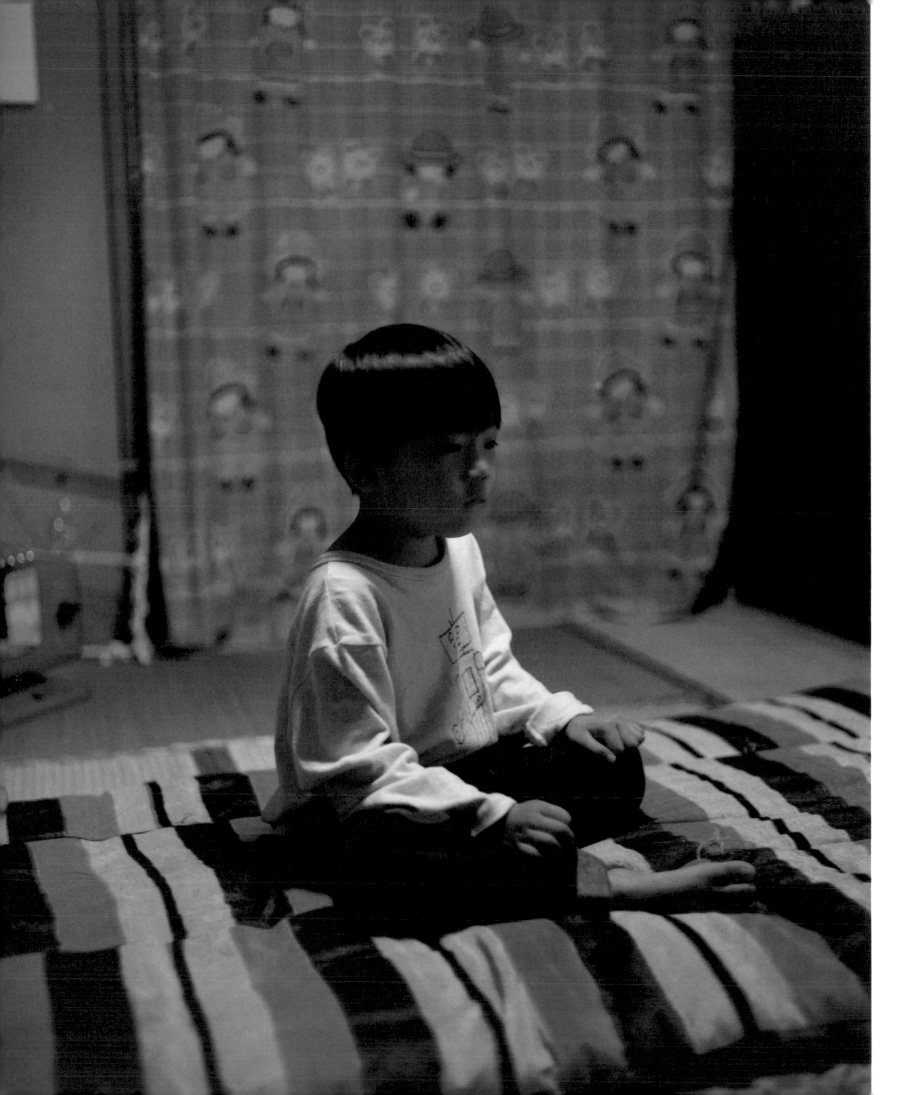

Television Portrait, Ryo, Tokyo
1995
Colour photograph
110 × 90 cm

Graham **If there's any kind of thread that runs across them, it's what we touched on about dealing with historical pressures, social pressures, and how that affects individuals, human beings, us. It's hard to know your threads because you're so close, and while history is a link between later works, it goes beyond that to a question of what societies and individuals conceal within themselves, consciously or not. Looking for those fissures that give it away, be it in a choice of wrapping paper or a hand gesture. Hopefully they extend into questions of individuality and identity, finding the right balance between individual freedom and social order, what price we must pay in society and the psyche to survive. These issues extend far beyond Japan, for example.**

Wearing Japan is useful because it's a society that hasn't been so fragmented.

Graham **Yes, it's strange, it seems by turns transparent and opaque, but it is self-contained, and that's why there's that picture of the bottle plant roots at the end of the *Empty Heaven* book, beautifully nurtured, yet trapped, unable to escape. Perhaps that's a cliché?**

Wearing It's like some unnatural growth as well. I like the idea that images use clichés, although that has such a horrible sound to it. But actually, though it's there all along, someone's discovering it. Pinpointing it is always the hardest thing to do.

Graham **Oh sure, piercing through the opacity of what it is now is very hard. But once it's done you immediately see it for what it is, and that's one of the tasks of artists. There's a line in *The Life and Opinions of Tristram Shandy*, by Sterne, where he says, more or less, 'Are we doomed to become like monks, forever parading the relics of our religion without ever performing one miracle with them?' And that's what happens. One forgets that that is the whole point, to say something, to work miracles ...**

Contents

In the diptych *Hirohito and Imperial Army Photograph, Tokyo,* 1990; *Rainbow Sugar, Tokyo,* 1995 Paul Graham forces a linkage between two images that are, at one and the same time, disjunctive and conjunctive. A black and white photograph showing Emperor Hirohito – a living god – surrounded by the officer corps of his Imperial army is juxtaposed with a close-up of a porcelain bowl containing rainbow sugar. The power and might of Imperial will bears little obvious relation to the inconsequentiality of a bowl of sugar, but the subject of Graham's work is the teasing out of a metaphorical language by which the mask, and masking, of history can be recognized and revealed through photography;

how history can be read through a bowl of sugar. Although he has always worked within the documentary tradition, Graham's work is not founded on some putative rhetorical idea of a barely mediated, authentic and untransformed truth. Instead he prefers the play of metaphor to the mechanics of emblematic portrayal based on the allegorical certainties of metonymy. By his use of the symbolic uncertainties of metaphor, Graham is able to present in his photographs what he calls, 'an alternative iconography that visualizes the invisible'.[1]

For the past fifteen years Paul Graham has, as a result, used the image of photographic objectivity as a tool so that the defining signs

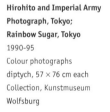

Hirohito and Imperial Army Photograph, Tokyo; Rainbow Sugar, Tokyo
1990-95
Colour photographs
diptych, 57 × 76 cm each
Collection, Kunstmuseum
Wolfsburg

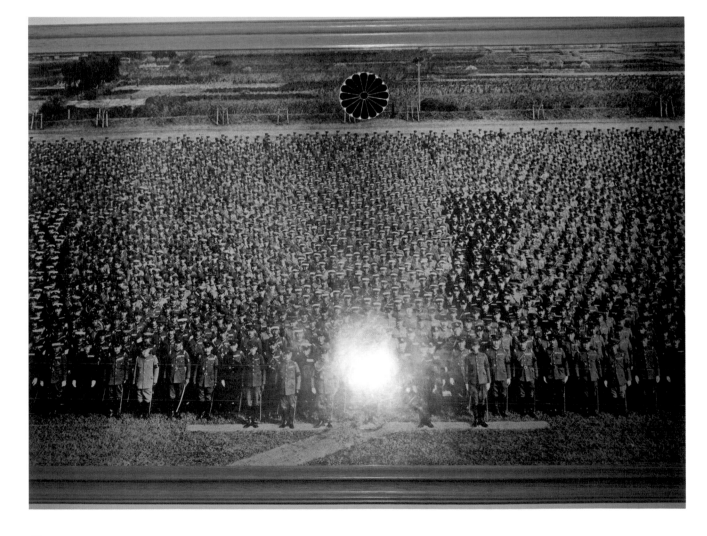

of contemporary life could be embodied within the structure of a corresponding re-evaluation of the place held by history. 'History is the subject of a structure which is not homogeneous, empty time, but time filled with the presence of the now [*Jetztzeit*]',[2] wrote Walter Benjamin. His is a view of history that is joined to the present, or is a slippage from the present which also occupies the core of much recent philosophical writing. To Jean-François Lyotard, for instance, the present offers (and is constructed from) a continual re-reading of history. History makes its appearance as an unpresentable present event. His view of contemporary culture, as a result, revolves around issues of veiling, the hiddenness or unpresentability of

something and the desire to reveal and present it.[3] The image of Japan's martial might controlled by an Emperor-God is one that has been consistently suppressed and covered over by the overall veneer of happiness. In his work in Japan and elsewhere, Graham has observed those isolated details and gestures which carry no exact definition and might hardly even deserve naming, but when viewed in a certain context hint at a wider condition that throws new light on the image of history that we all carry with us and which determines the way we think.

Paul Graham has described his preoccupation as a concern with unlocking strategies of 'concealment'. How the particular defining history of, for

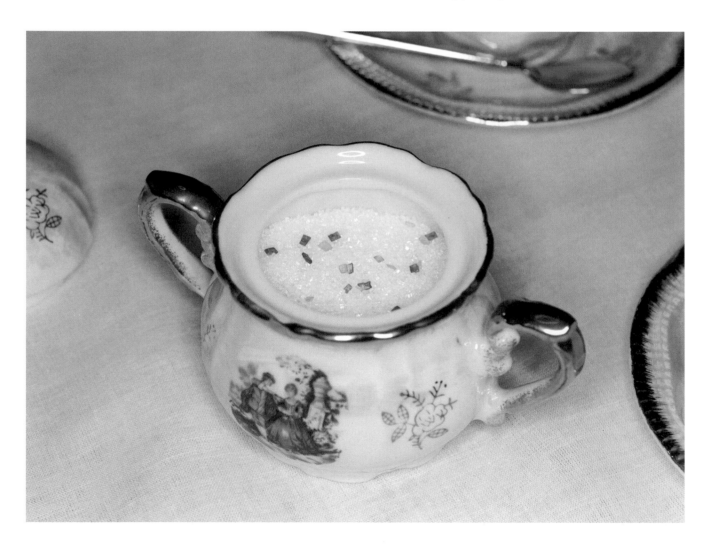

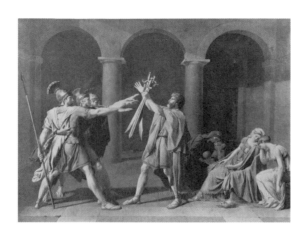

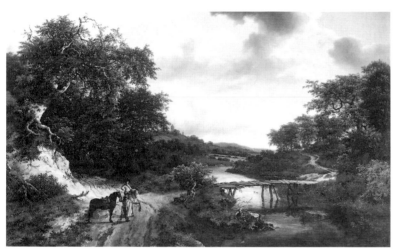

Jean-Jacques David
The Oath of the Horatii
1786
Oil on canvas
130.2 × 106.7 cm

Jacob von Ruisdael
The Wooden Bridge
1652
Oil on canvas
99 × 159 cm

Jean-Baptiste Greuze
The Village Brothel
1761
Oil on canvas
92 × 117 cm

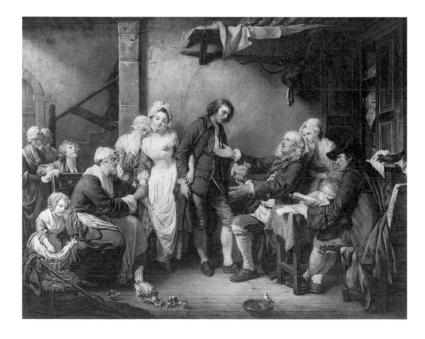

instance, 'the Troubles' in Northern Ireland can be concealed within the landscape, in much the same way as the narrative of agrarian reform in the eighteenth and nineteenth centuries was concealed within the landscapist strategies of John Constable or the rural genre scenes of George Morland. Or, in another sense, how the particular histories of wartime Japan or Europe are concealed through state and cultural imperatives; how the bureaucratic, demilitarized, mercantile psyche of contemporary Japan that hides itself from the past can be revealed in a bowl of sugar. Although the past will always leak through into the present, by the fact of its concealment the present also has the ability to offer another amended reading of that history.

Graham's work provides a reading of contemporary life that cannot help but be infected by the example of the past. His intention, however, is very different from the idea of History Painting that used religious, epic, heroic, antique or other elevated themes as a way of commenting on the present by using what Diderot described as the *grand goût* or *grande manière*. For example, Jacques-Louis David's use of a historical model in *The Oath of the Horatii*, 1785, could stand as a pre-Revolutionary manifesto for the French Republicans. Graham's approach to history is not so straightforward. Instead he enacts a reversal which stresses his use of the present to gain a perspective on the past, which can then be reflected back onto the present. Closer to Graham's position, and certainly to the work that forms *A1, The Great North Road* (1983) and *Beyond Caring* (1986), is the work of Jean-Baptiste Greuze in

France after 1760, in which an attempt is made to approximate genre painting to history painting, or in England the painting and graphic works of William Hogarth that were termed 'moral' or 'comic' histories.

Where Graham moves sharply away from such a position is his refusal to produce an idealization of his subject matter, or an image which occupies an overtly moral, fully propagandistic or partisan stance. In this he has some affinity with Walker Evans who, while photographing sharecroppers during the Depression, refused to believe in photography's capacity to 'improve society' or even to adopt such a propagandist position.[4] Graham does not intend to alter the life his camera focuses on but instead aims at finding a way to know it and reveal the forces that shaped such a condition. This approach marks a crucial difference between his own work and the work of British documentary photographers, such as Martin Parr or Chris Killip, with whom he was often compared in the early 1980s. Another example of the multiple-coding that Graham's images exploit is suggested by the misreading of the Dutch landscape and genre painters of the seventeenth century. A century later, during Hogarth's time, these artists were thought to have lacked any conception of the ideal and to be incapable of producing art not based on direct observation. Such paintings were believed to be a bare documentation of reality. This, however, ignored the emblematic nature of the genre picture or the fact that landscape could provide the devout Calvinist not only with a surrogate for a religious painting but also with an image in which was inscribed the nature of Dutch identity and its mercantile status through an image of property. The 'objective' use of a medium like photography, just as much as an openly symbolic presentation of an image, is always going to be subject to its reading as much as its intention.

It is in this respect – of a reading and a misreading – that Graham uses the 'objective' eye of the camera to question the facticity of the resultant image – to show that historical reality (and by extension present reality) otherwise resides both hidden from, and within, that process of reading. On one hand the moral subject is there to be recorded, instead of fabricated, and on the other hand history exists, more strongly, as something hidden in the present, as opposed to separated from the present. There has emerged, in recent works, a kind of artless matter-of-factness in the way in which Graham achieves this. The photograph of Hirohito is photographed as any of us would see it in a museum, the camera is hand-held, the frame cuts into the image and Hirohito is himself rendered invisible in the flash of his camera. This, figuratively, emphasizes the extent to which he had been removed from culpability in any crimes that had been carried out in his name, while the sugar is similarly subject to a form of childish delight by the addition of a few artificially coloured grains. A happy glow is, in this way, cast over a collective amnesiac melancholia. In these photographs past and present exist on the same skin.

Graham's first step was his adoption of colour film over black and white. He was encouraged to do this after encountering the work of

William Eggleston
Snak Shak, Montezuma
Colour photograph
25.4 × 38.1 cm

William Eggleston, whose 1976 solo exhibition at the Museum of Modern Art in New York – 'William Eggleston's Guide' – offered institutional acceptance of the colour print where it had hitherto been judged to be nothing other than vulgar and trivial. Of similar significance to the manner in which Graham's work has developed was the example of Eggleston's 1977 portfolio *Election Eve*. This series of 100 photographs was made around Plains, Georgia, in the month prior to Jimmy Carter's election as US President. The linkage of disregarded everyday images with a momentous event of historical importance proposed a strategy that Graham has consistently enlarged and exploited in his work. Most recently, and graphically, it was adopted in his series of cloud photographs taken throughout Northern Ireland during the I.R.A.'s initial ceasefire in April 1994.

The subject-matter of Eggleston's photographs – interiors of cafés or barely inflected landscapes of the American South – proposed a poetry of the backyard whose status was elevated by his adoption of richly super-saturated colour (achieved through dye-transfer printing). Eggleston defined this method in his book *The Democratic Forest* as 'the idea that one could treat the Lincoln Memorial and an anonymous street corner with the same amount of care and that the resulting two pictures would be equal, even though one place is a great monument and the other might be a place you'd like to forget'.[5] What Graham later came to realize was that the photograph of the street corner could exist as an objective record and yet still contain the resonance of cultural history that could be found in the photograph of the monument. Furthermore, such an affective linkage was all the more powerful for being partially hidden from sight either through a lack of an immediate recognition or because the traces had been covered over; a hidden set of meanings could, as a result, attain the force of primary meaning. In this respect Graham's project moves away from reportage towards an interrogation of the mechanics in which history and morality are treated within contemporary life, and how, at the same time, the single image could capture both polarities. Graham was able to free his photography from the craft aspects that bedevil much art-photography – the concern with photographic process over image-construction – and the use of colour was an important aspect of this new freedom.

By virtue of their subject-matter – café-interiors, for example – some of Graham's earliest colour photographs do indeed echo Eggleston's photographs. But the work that made up his first solo exhibition at the Ikon Gallery in 1980, *House Portraits*, put into high relief the singular nature of his use, and questioning, of photographic objectivity. Using a large-format camera, he made metre-high photographs of modern detached houses from suburban housing estates that he described as 'dead straight, blunt and full-on'.[6] By virtue of their composition they recalled the work of Bernd and Hilla Becher, Lewis Baltz or Frank Gohlke, which Graham had first come into contact with through 'The New Topographics' exhibition that had been mounted at the George Eastman House in Rochester in 1975. This exhibition

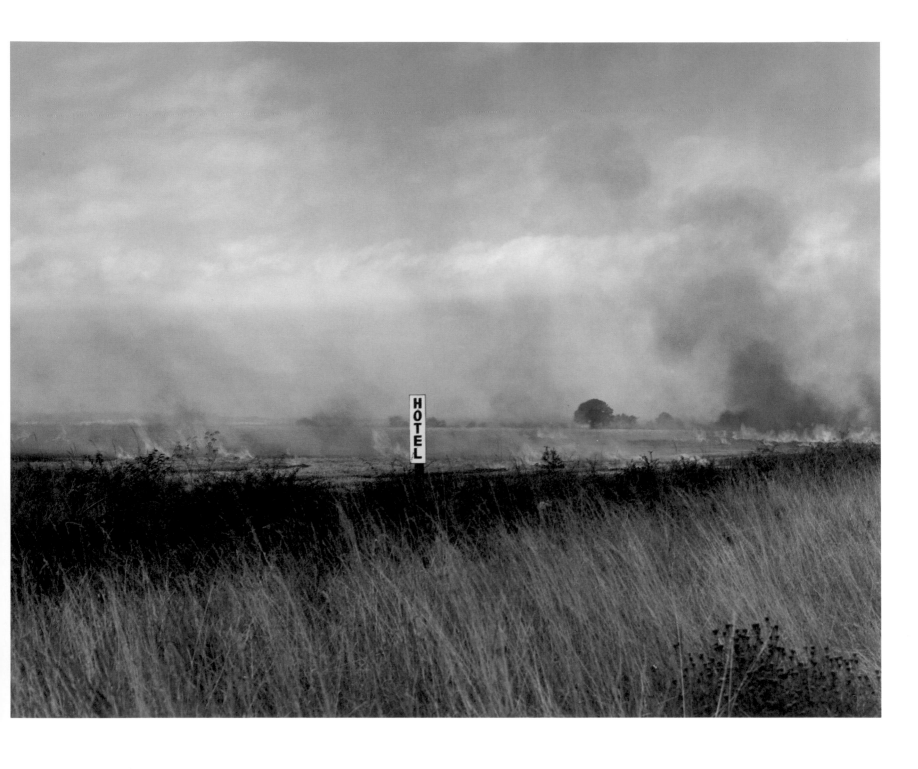

Burning Fields, Melmerby, North Yorkshire, September
1981
Colour photograph
40 × 50 cm

defined a new approach to the language of the photograph as documentary image – 'pure subject matter'[7] – that was to make some impact on Graham. Such photographs offered no judgement beyond finding a process that would hold a historical or formal analysis of what was in front of the camera. In this respect meaning was made by the linkage between the work's conception and its transformation of the seen world into an image: 'The two distinct and often separate entities of actual, physical subject matter and conceptual or referential subject matter can be made to coincide. It is this coincidence – the making of a photograph which is primarily *about* that which is in front of the lens – that is the central factor in the making of a document'.[8] However, the content of Paul Graham's photographs does not construct some sort of disinterested formal and anthropological typology, as the work of the Bechers does, and can be more usefully compared, for example, with the social and political underpinning of Dan Graham's 1965 photographs of typical suburban houses.[9]

Unlike the majority of artists in 'The New Topographics', Graham presented this facticity through colour film, and thus the world of the amateur photographer and the holiday snapper entered the world of factual analysis. Although these works were subject to a rigid compositional structure this was less obvious in his next body of work, *A1, The Great North Road*. The *House Portraits* and much of *A1* could be described as compositionally understated, impersonal and reticent. It is not that they are necessarily ordinary but that they register a snapshot aesthetic. These images are constructed by what could be termed

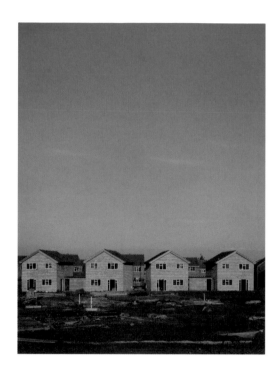

a 'passive framing' as opposed to the social documentarist's 'active framing'.[10] This distinction has little to do with actual compositional structure but more with the intention towards the reality that is held fast by the camera and governs the final character of the photograph. 'Active framing' results in an overt commentary on a world that is clarified and distorted by the camera to fit into a pre-ordained symbolic order. Much photojournalism fits into this condition. By distinction, 'passive framing' recognizes the fragmentary nature by which the camera finds its image so that the subject's significance becomes more mobile.

Graham has explained *A1* in terms of travelling along the Great North Road as the prelude to his childhood family holidays in Cumberland.

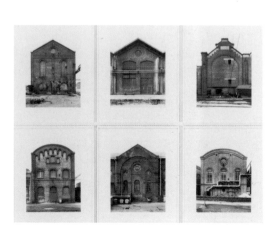

**Little Chef in the Rain, St. Neots,
Cambridgeshire, May**
1982
Colour photograph
40 × 50 cm

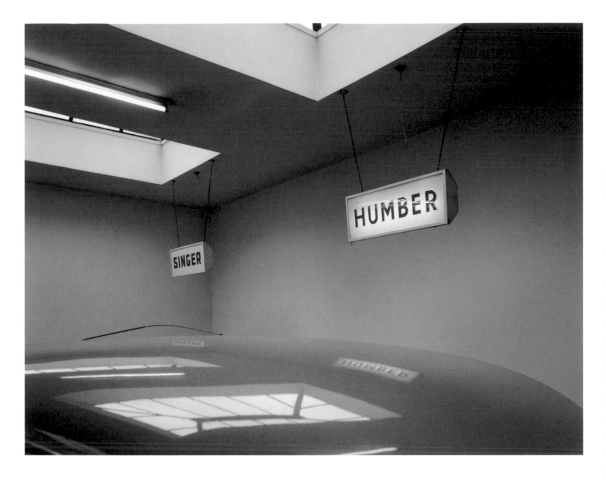

**Great North Road Garage,
Edinburgh, November**
1981
Colour photograph
40 × 50 cm

However, if the series does suggest an exercise in personal nostalgia the photographs express this as a shared sentiment, in which traces of the past could be uncovered within the way we treat the landscape. The forty photographs that make up the series variously present a world of unkempt scrub, grass verges, road intersections, the meeting of land and sea, motel and café interiors, portraits, car and lorry parks, rain-swept fields and stubble-burning, service stations and bus stops. The A1, or Great North Road, once the main arterial road from the South to the North of England, is shown by Graham to be a world that is defined by its borders in which drivers are isolated and alienated from each other as well as from the landscape they pass through. He turns his camera away from the road itself and onto the unseen, uncared-for and misused landscape and people that he found

around the road's lay-bys. The world that is described in photographs such as *Little Chef in the Rain, St Neots, Cambridgeshire, May,* 1982; *Burning Fields, Melmerby, North Yorkshire, September,* 1981; or *Looking North, Newcastle By-Pass, Tyne and Wear, November,* 1981, is one that recalls Ian Nairn's attack, in the late 1950s, on the spread of road building and the resultant blurring of the natural and urban environments. Temporary signs, advertising hoardings, pylons carrying power cables, sites of heavy industry, along with the inevitable decay that accompanies such places, disturb what Nairn termed the 'unity of the place'.[11] It is this blurring of boundaries, and the meanings that can be obtained from the traces left by the past, that fascinates Graham, but in two quite distinct ways.

In images such as *North Sea, Borders, May,* 1981 and *Looking North, Newcastle By-Pass,* Graham looks away from the road; in the former, the tarmac road joins a grass verge which meets the sea at a point where the A1 passes near Berwick, between England and Scotland. A sense of passage is described by an image of stillness, and a sense of change by an image of uniformity. Similarly, in *Looking North,* what we see is the effect of the road on the landscape – rather than the road itself – in the form of a hedgerow along which is lined a pylon, a road sign, an industrial chimney belching out smoke, caravans, a petrol station and a solitary car. Meaning, or the content of these images, is described by the nature of this linkage. John Barrell's description of how the contemplation of landscape involved its recognition 'as a complex of associations and meaning,

Petrol Station, Blyth Services,
Nottinghamshire, March
1981
Colour photograph
40 × 50 cm

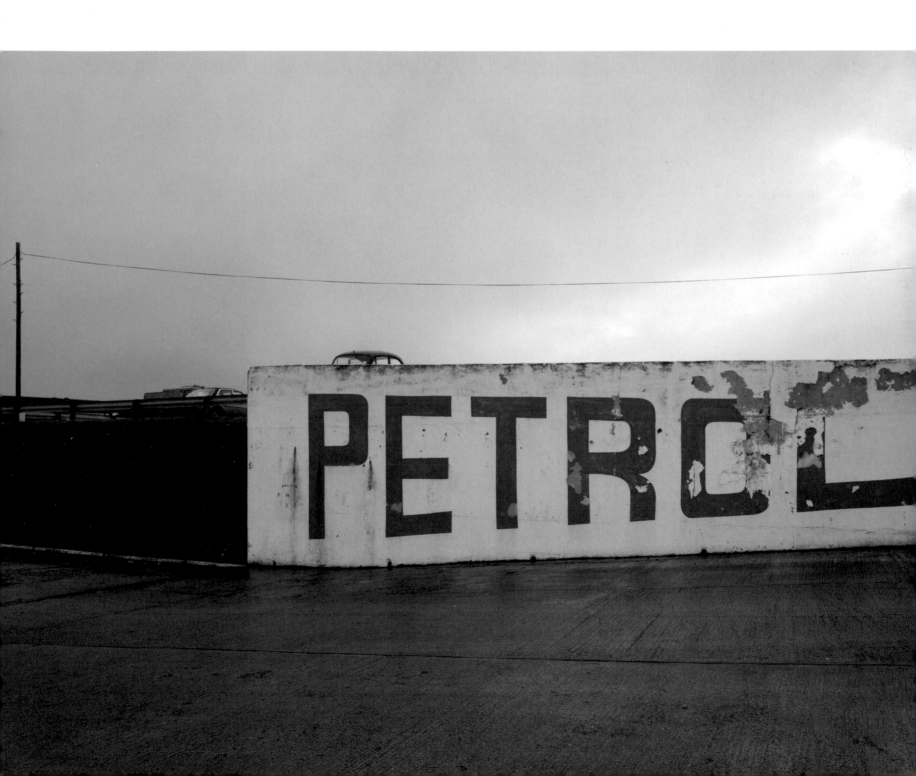

and, more important, as a composition, in which each object bore a specific and analysable relationship to the others'[12] typifies Graham's approach, especially with respect to *A1* and *Troubled Land*. Where the *House Portraits* provide an image of a structured wholeness, the images in *A1* are fragments, and this one-time arterial road is defined by the edge and the border, rather than the unified centre.

In other images – *Great North Road Garage, Edinburgh, November,* 1981; *Petrol Station, Blyth Services, Nottinghamshire, March,* 1981; or *Mac's Cafe, Alconbury, Cambridgeshire, April,* 1981 – this sense of linkage is of an altogether different, and more archaeological, order. The road has been left behind and Graham's camera is held by the anachronism of peeling paint that points to a time when he travelled on the road as a child in the back of his parents' car. In *Great North Road Garage,* the signs for Humber and Singer cars still stand illuminated even though they had ceased production some years earlier. In the other two images the signage for 'Petrol' points to another time, while the three different signs for 'Mac's Cafe', one of which lies discarded on the ground, charts the establishment's history typographically. The landscape's meaning is described here not as a spatially defined linkage, but one that is fixed by time.

There is only one image in *A1* in which the people are not described as generalized types – drivers, young executives, company represen-tatives, café assistants or day-trippers. In *Drivers Discussing Redundancies, Morley's Cafe, Markham Moor, Nottinghamshire, November*, 1981, the

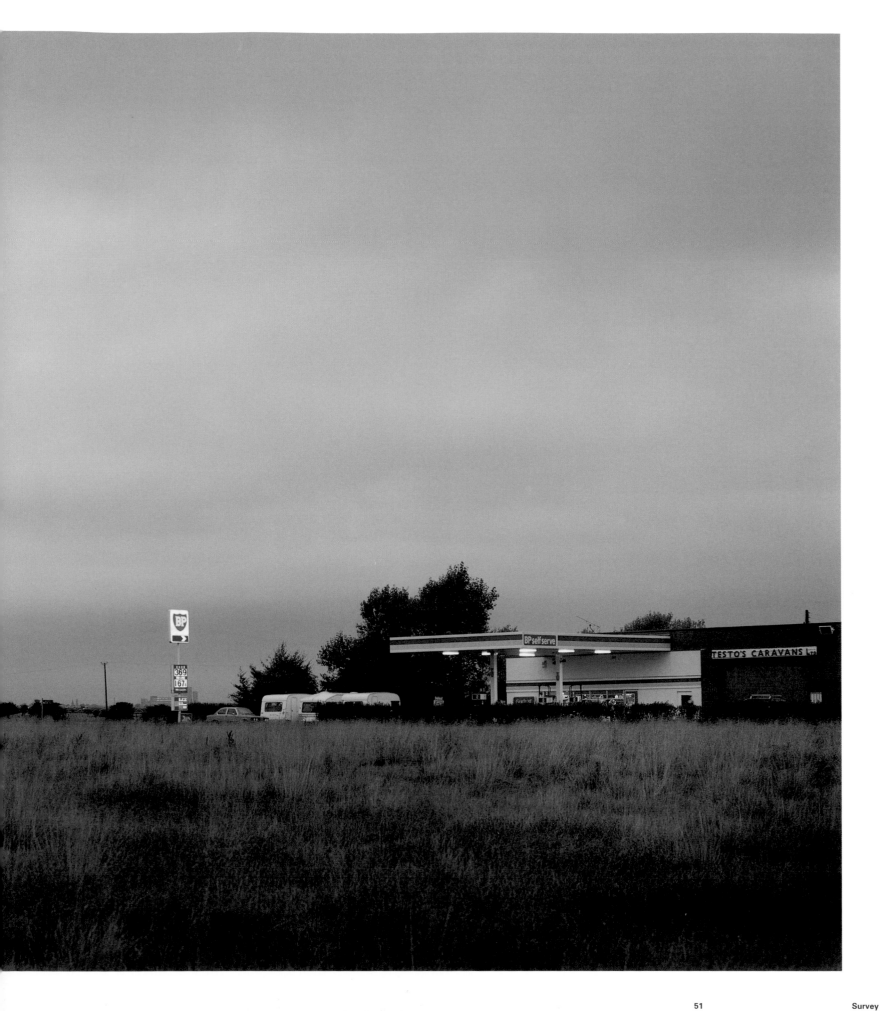

Young Executives, Bank of
England, London, November
1981
Colour photograph
40 × 50 cm

subjects are shown to be engaged in a particular activity that marks them out as figures who would be pushed to the margins of society. This is paired with *Ashtray on Table, Morley's Cafe, Markham Moor, Nottinghamshire, February*, 1981, a frontal and heavily foreshortened view of an empty table with two chairs marked by the abject traces of past occupation: cigarette butts in the ashtray, scuffed walls and worn-down, burnished, wooden seat-backs. The sequence from full café to empty table is deliberate. The two men in the centre of the first photograph discuss their removal to society's margins. One is still eating, mouth full of food, while the other clutches at his wallet, held

between his fists. Around them sit younger men talking, reading the newspaper or finishing a crossword. In the next photograph they are gone, but they *had* been there.

There is, perhaps, something about the conjunction of these photographs that jars with the less determined nature of the rest of the series. We cannot hear what the drivers are discussing but the caption tells us, and the message is inescapable. A wallet gripped between the fists, and the expression of a man caught in the act of eating are innocuous and hardly noticeable gestures, but in the context of a discussion on redundancy, they invest the image with a degree

**Drivers Discussing
Redundancies, Morley's Cafe,
Markham Moor,
Nottinghamshire, November**
1981
Colour photograph
40 × 50 cm

of poignant helplessness. This casual, everyday image has become, through Graham's eye, a hard and permanent symbol. An image of marginality is described in this photograph with absolute clarity while, in the rest of the series, the margins and boundaries provide a place where a veiled meaning might be found. In *A1* Graham supplies us with images of time arrested. The road, which had been superseded as an arterial road by the M1 motorway, takes on the character of a historical fragment, where cafés and garage forecourts become an anachronistic stage in which people exist out of joint with the times. These people are also caught within the first effects of the Thatcher government that was exercising its military will in the Falklands and Northern Ireland as well as its economic strategy, of deregulation and privatization, on the general population. Graham's concern may ultimately rest with history but his camera is arrested by its effect, primarily, on people. History to Graham is not an anonymous force. During this period Graham's work became more political, and *Beyond Caring* was the result of his inability to sit on the fence. In these works Graham engaged closer with this emblematic procedure in a way that is superficially reminiscent of the satirical engravings of Hogarth or seventeenth-century Dutch genre paintings, even though the intention is of an entirely different order.

Beyond Caring had its beginnings in an exhibition of documentary photography sponsored by The Photographers' Gallery in London, 'Britain in 1984'. Graham travelled around Britain and to Northern Ireland, garnering a variety of images

that had each been plucked from very different situations and which he hoped would 'communicate something of the mixture of anxiety and apprehension, sadness and affection with which I view the current state of our nation'.[13] Comparisons between these photographs and the genre paintings of Jan Steen, or with engravings by William Hogarth such as *The Times, Gin Lane,* 1751, however, miss the point. The photographs in *Beyond Caring* are not determined solely by a specific moral purpose or alternatively by a rigidly emblematic iconography; they do not use caricature and are not satirical. They offer a statement of fact. Of how Bevan's utopian vision of a postwar Welfare State had been run down into a state of absurd decay. How the present had turned its back on history's promise.

A sense of a failed history (or one that was allowed to fail) haunts these photographs. Instead of a portrayal of picaresque nullity we witness a world peopled by listless victims of bureaucratic obduracy. What Graham records is an interior landscape of traces of an existence that had been swept under the carpet. In photographs like *Doorway, Dole Office, Hammersmith, West London,* 1984; *Men Waiting, Whitechapel DHSS, East London*, 1985; or *Waiting Room, Highgate DHSS, North London*, 1984, one sees out-of-date signs, peeling Sellotape, walls that have been scratched into, worn and written on, and litter that has been discarded by those who, in turn, have been abandoned by society: cans of beer, sweet wrappers, cigarette butts and empty packets, paper hankies, milk cartons and bottles, plastic cups, crisp packets and forms that have been thrown away

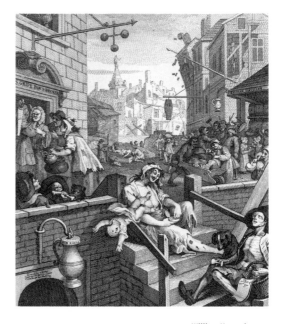

William Hogarth
The Times, Gin Lane
1751
Engraving
35.5 × 30.5 cm

unfilled. Graham had exchanged his large format for a hand-held camera and adopted a low viewpoint that scanned the floors and, in looking up, was overshadowed by the rest of the room. History is presented not by the grand statement – Diderot's *grande manière* – but by the effect it has on the way people's lives are led.

Evidence for the consistency with which Graham has approached this strategy is provided by two photographs: *Beer Can and Feet, Walthamstow DHSS, East London,* 1985, from *Beyond Caring* and *Untitled, Belfast, 1988 (bricks under skip)* from *In Umbra Res* (1990). The earlier photograph is certainly more illustrative in its use of image, in demonstrating how people waiting in the benefit office are perceived as being analogous with the rubbish at their feet, as just so much discarded waste. The later photograph, a metre and a half high and two metres across, shows three disintegrating bricks propping up a skip, creating a monument to their almost Sisyphean task. A discarded can of Harp lager lies out of focus in the veiled background, but our attention is held by the three bricks, a sobering metaphor for the fragility of existence and the weight brought to bear on ordinary people by 'the Troubles' in Northern Ireland.

The two photographs taken at Poplar during the same afternoon – *Waiting Room, Poplar DHSS, East London,* 1985 and *Man with Crutches, Poplar DHSS, East London,* 1985 – create a panorama of entrapment in which the unemployed are caught and hidden away. Graham does not view these people from afar but traps his camera in these small rooms as they are, themselves, entrapped.

The figures in *Beyond Caring* are shown intently waiting for their number to come up. These woefully inadequate rooms – small box rooms, cubicles, plateglass-fronted counters –are the late twentieth-century equivalent of the Dickensian workhouse, shrouded from a society that doesn't want to know. If a characteristic of Graham's work is registered by his use of linkage, these photographs stand apart. The people have little part to play in government strategy, except as an embarrassment. Whether the rooms are crowded or almost empty, these people are wholly alienated and isolated from society and from any form of social interaction. As they sit or stand, Graham's subjects are like an audience in a theatre where, faced by nothingness, all they can do is gaze blankly into space.

One aspect of *Beyond Caring* is the way in which Graham uses the signage found within the benefit offices as a means of providing a primary subject to the image. There are the faceless bureaucratic instructions that reinforce the human separation between those on welfare and those from whom they receive it – 'Your Turn Automatically', 'Fresh Claims This Way', 'In The Event Of The Fire Alarm Sounding Please *Remain* Where You Are Until Instructed Otherwise'. There are those images which, although not information signs, also reinforce the marginal status of people receiving welfare – a poster of a horse in an office in Bristol, an enlarged illustration from Dickens' *Pickwick Papers*, a mural-sized poster of an Alpine landscape, a poster from the Welsh Tourist Board. Lastly there are those signs – 'Good News'; 'We have many new vacancies each day. If you are still

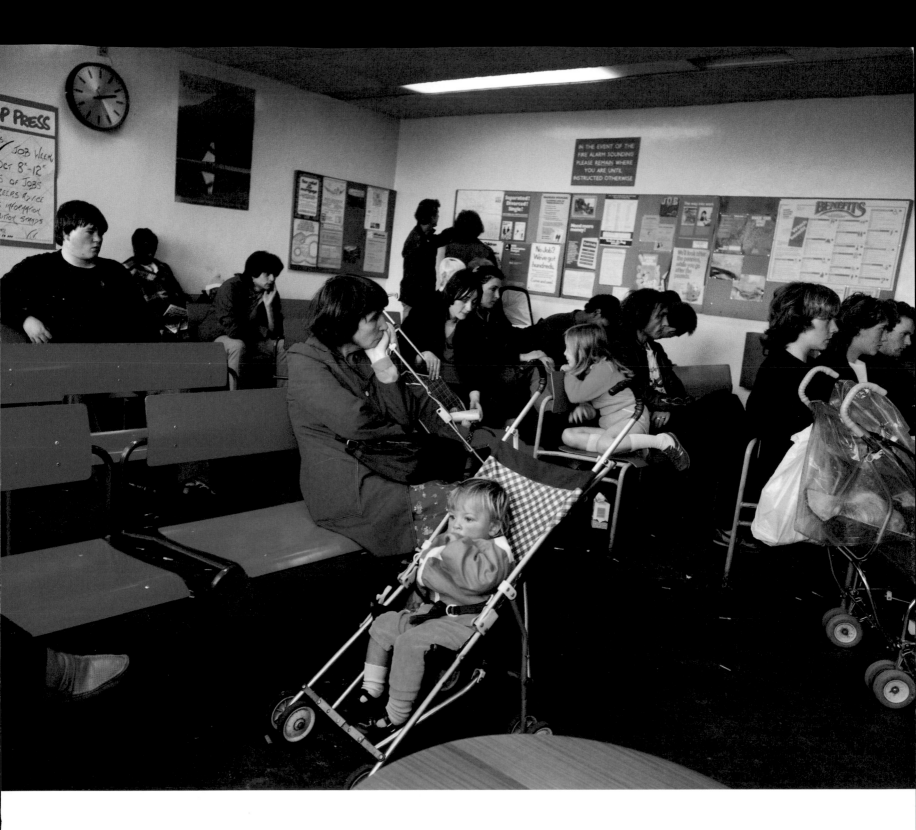

**Mother and Baby, Highgate
DHSS, North London**
1984
Colour photograph
68 × 87.5 cm
Collection, Arts Council of Great
Britain, London

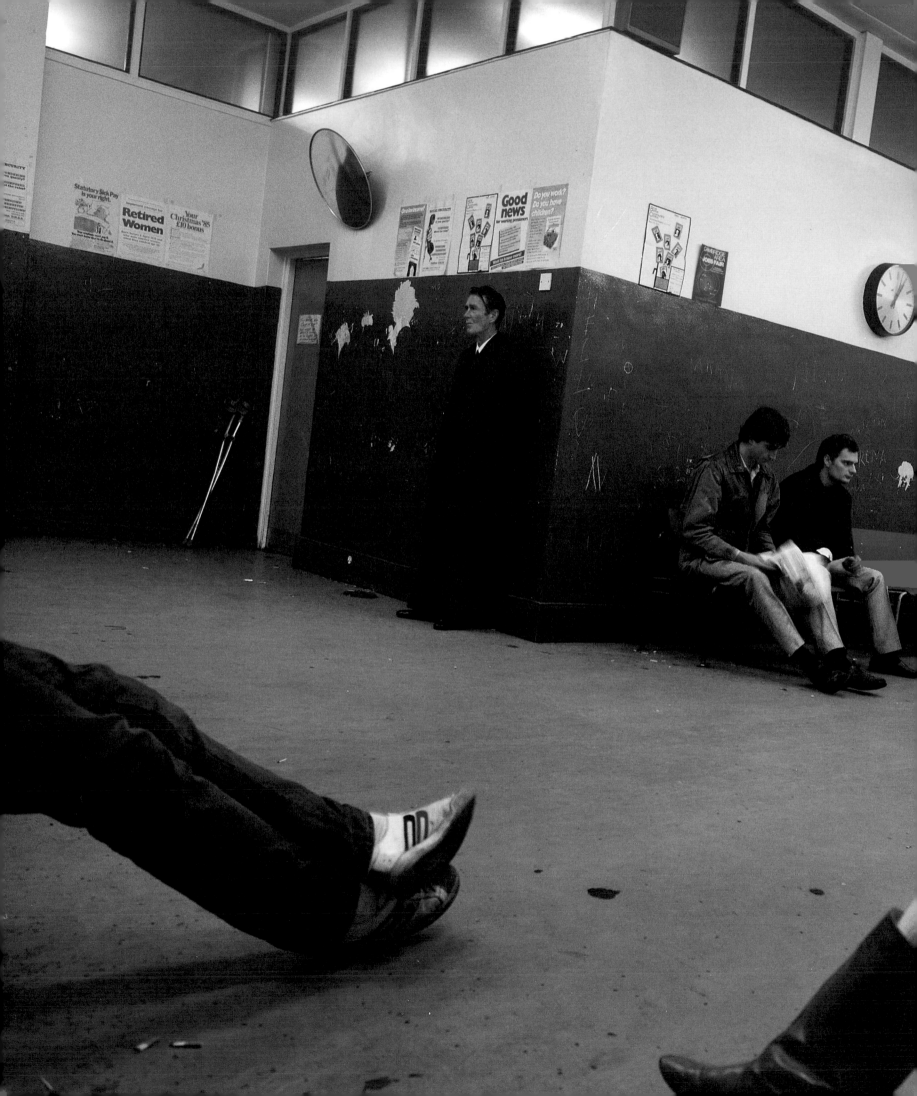

Waiting Room, Poplar DHSS, East London
1985
Colour photograph
68 × 87.5 cm
Collections, Arts Council of Great Britain, London; Rhode Island School of Design, Providence

**Man Reading Paper, Bloomsbury
DHSS, Central London**
1985
Colour photograph
68 × 87.5 cm

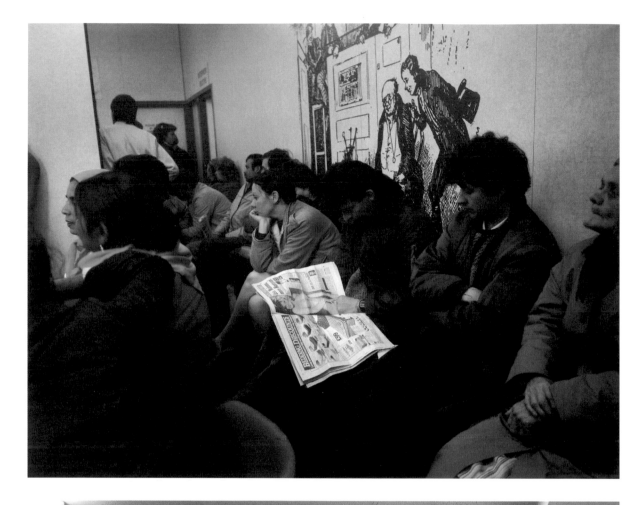

**Mural, Camberwell DHSS, South
London**
1985
Colour photograph
68 × 87.5 cm

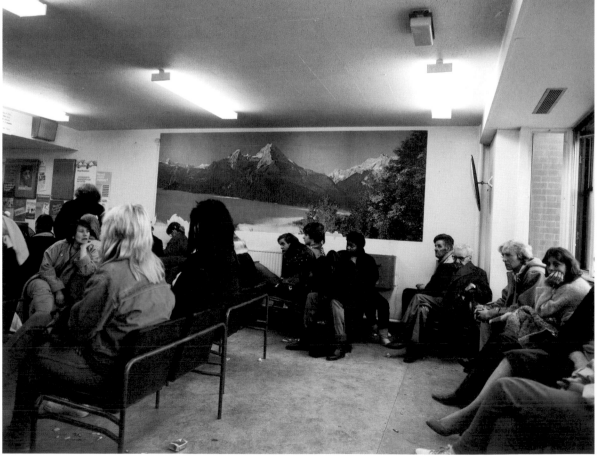

looking for a job, call again tomorrow' – that although intended to offer hope reinforce the despair that is portrayed by the graffiti that covers many of the walls that Graham pictures. In each case, as a result of the context in which they have been placed, Graham uses these signs to signify something other than was originally intended. Such signs encourage an extra-pictorial linkage in the mind of the viewer; a linkage founded on the signs' own presentation of a multiple-coding. The Alpine poster, while there both to 'hide' deprivation as well as to offer an imagined escape from the benefit trap, because of its fictional and illusionistic purpose also serves to emphasize the extent to which it represents an impossible dream. Graham has consistently extended this strategy in his recent work, so that a Japanese candy wrapper or a photograph of the cloud from the atomic bomb over Hiroshima are recontextualized to hint at their, possible, true significance within a society which has consistently wrapped-up its history.

In 1984, Graham made his first visit to Northern Ireland. If the subject of *Beyond Caring* was framed by the economic violence carried out by the State, the photographs that emerged out of his visits to Northern Ireland – *Troubled Land* (1987), *In Umbra Res* and *Untitled* (*Cease-fire*) (1994) – are framed by the terror of that particular conflict. However, where the nature of *Beyond Caring* could be characterized by Graham's use of documentarist strategies, the manner in which he approached the subject of Northern Ireland was altogether more oblique and, initially, pictorially detached. Graham's photographs stand aside from the accepted imagery of this conflict, which is

subject to the demands of television and newspaper reportage. Traditionally the photojournalist takes his camera close to the action. The journalist either runs beside the subject – or at least appears to – by the use of a tele-photo lens. Nevertheless, such photographs can only project an illusion of truth, given the rigid framing devices that are used. On August 15, 1989, the day after the twentieth anniversary of the despatch of British troops to Ulster, many newspapers carried similar photographs of children throwing stones at the troops. However, the photograph by Herbie Knott run by the *Independent* showed the extent to which that image had been created as the possible result of media presence. Such pictures created by or for the camera, although of symbolic value, can have little value in terms of news, and no value in terms of truth.[14]

Paul Graham's earliest photographs of Northern Ireland, *Troubled Land*, appear, by distinction, almost devoid of people. They show that it is impossible to separate the landscape of Ulster, and all that it stands for, from the marks of conflict. Ever since partition in 1921, the landscape of Ireland has been defined by borders and boundaries both unseen and seen. *Army Stop and Search, Warrenpoint,* 1986 gives an indication of the complexity of Graham's strategy. The photograph at first appears to follow the

Horse Poster, DHSS Office, Bristol
1984
Colour photograph
68 × 87.5 cm

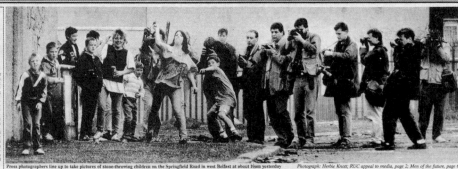

**Army Stop and Search,
Warrenpoint**
1986
Colour photograph
68 × 87.5 cm
Collections, Winnipeg Art
Museum; Wolverhampton Museum
and Art Gallery

tradition of the compositionally neutral landscape. A stretch of water occupies the left side of the image, a road winds down the right side from which land gently rises and trees give the composition a classically one-sided axis. Where the road bends we see the town of Warrenpoint; in the distance hills rise to the horizon. However, just before the curve in the road a car has stopped and two soldiers have approached it. At this point the normality of the landscape has been ruptured to form what Jerry Saltz termed 'a cancerous vision of the landscape – a place where tiny signs appear of great unrest'.[15] Where the photojournalist would have used a tele-photo lens to capture the exchange between motorist and soldiers, Graham has pulled back to capture the context that defines that action. Looked at in this way, the compositional meaning of the photograph, as opposed to its pictorial structure, is not one-sided; the water that is shown here at low-tide – Carlingford Lough – marks the border between Eire and Northern Ireland, which leads into the 'bandit country' of Armagh some ten miles further west. The actual subject of the photograph becomes not the one incident, the act of this particular stop and search, but the way in which the geography of 'the Troubles'

is held as a continuous narrative within the landscape itself, in which everything is charged with significant meaning.

Over the last twenty years, writing about the representation of landscape in art has been turned on its head, most notably by John Barrell. The aesthetically neutral landscape has been exchanged for a landscape heavy in signification. It is in the light of such commentaries that Graham's work must be read. When *Troubled Land* was first exhibited he was criticized for not adopting the partisan position of a photojournalist, for not getting 'close' to his subject, for portraying 'the Troubles' as 'incidental' to a landscape which, as a result, was shown to be 'normal'.[16] This is to ignore the extent to which the subject of 'the Troubles' is so etched into the landscape that it is impossible to see one without the other. Furthermore, the often discrete, hidden nature of the marks that scar the landscape – political posters hung so high that they cannot be torn down, observation posts and distant helicopters shrouded by trees, a union jack flying from an isolated tree-top, the splatter of paint in the Unionist or Republican colours, over roads, onto the sides of building or painted over kerb stones – an historically-informed graffiti of violence, division, hatred and bigotry – is all the more powerfully resonant for being caught in this way. An early engraving by Esaias van de Velde, *The Gallows,* 1614, provides in this respect a useful comparison to Graham's *Army Stop and Search, Warrenpoint*. A centrally placed winding road recedes into the middle-distance of this low-horizon, panoramic landscape. Figures walk down

Esaias van de Velde
The Gallows
1614
Engraving

E.V.VELDE. fecit.
1. P. Beerendrecht. excud.

**Army Helicopter and
Observation Post, Border Area,
County Armagh**
1986
Colour photograph
68 × 87.5 cm

**Union Jack Flag in Tree,
County Tyrone**
1985
Colour photograph
68 × 87.5 cm
Collections, British Council,
London; National Museum of
Film and Photography, Bradford;
Wolverhampton Museum and Art
Gallery

the road, wrapped up in their own actions. To the
right, on slightly rising ground, with some trees
punctuating the horizon, cows graze, oblivious of
the symbols of state and judicial oppression that
stand at the very edge of the landscape: a torture
wheel and gallows. A supposedly neutral landscape
is in this way unbalanced, its meaning rendered
unstable and compositional unity fragmented.

Graham is not interested in the depiction of a
landscape as either neutral or natural in *Troubled
Land,* but in the presentation of that landscape's
multiple-coding. The marks and traces of conflict
cannot be separated from the landscape in which
they are found nor from the conventions of the
representation which they also deface. Here
nothing is innocent of its surroundings. The land-
scape composition suggests a benign normality
through which aberrant details and history slip.
The making of a pictorial meaning in these
photographs hinges at the point of slippage in
which these conventions meet and are continually
upset and rendered problematic in the face of a
collateral meaning. The nature of this particular
landscape alters in a similar way to the manner
in which the early nineteenth-century agrarian
landscape can be read in paintings by Constable,
such as *Fen Lane, East Bergholt, c.*1817, or, of the
same spot from a different angle, *The Cornfield,*
1826. These paintings may be read as an evocation
of a pastoral idyll while, at the same time, the
depiction of the workers in the fields – as absorbed
in their work as they are in the landscape and
almost hidden from view by the line of the field –
suggests that a state of continual labour provided
the actual foundation for Constable's pastoral view

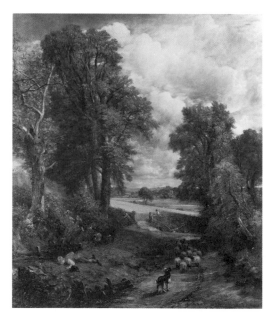

John Constable
The Cornfield
1826
Oil on canvas
143 × 122 cm

Republican Parade, Strabane
1986
Colour photograph
68 × 87.5 cm
Collections, Museum of Modern
Art, New York; National Museum
of Film and Photography,
Bradford; Wolverhampton
Museum and Art Gallery

H-Block Prison Protest, Newry
1985
Colour photograph
68 × 87.5 cm

following pages, **Paint on Road,
Gobnascle Estate, Derry**
1985
Colour photograph
68 × 87.5 cm
Collections, National Museum of
Film and Photography, Bradford;
San Francisco Museum of Modern
Art; Wolverhampton Museum and
Art Gallery

of the Suffolk landscape.[17]

Bearing in mind such readings, the natural appearance of the landscape, the human presence and the burden of history provides a matrix that creates a fragmented and multi-layered whole. Against the compositional and clichéd tightness of the newspaper photograph, Graham's photographs encourage a deeper, richer and more complicated reading. The comparison of a typical news photograph of the conflict in Northern Ireland with *Roundabout, Andersonstown, Belfast,* 1984 reveals a gulf that had been signalled by Roland Barthes in *Camera Lucida*. The work of the photojournalist was for Barthes essentially banal, and in such images there was only 'a certain shock – the literal can traumatize – but no disturbance; the photograph can "shout", not wound. These journalistic photographs are received (all at once), perceived. I glance through them, I don't recall them; no detail (in some corner) ever interrupts my reading: I am interested in them (as I am interested in the world), I do not love them'.[18] In the archetypal newspaper photograph the conflict is presented as a spiralling succession of incidents and their aftermath. These images can only provide an illustration and cannot explain what has happened in front of the lens; divisions, questions of identity and history are conflated by unitary presentation. Given such a stage, the eye of the camera can only present a carefully constructed, and allegorical, illusion. They have both to illustrate and be a surrogate for the story caught in a fraction of a second. By pulling back from such flashpoints Graham allows his photographs such as *Roundabout* to occupy a

different sort of stage. This image is made up of fragmentary details that disturb through allusion rather than literal presentation. Having refused to focus on a single event, Graham provides the viewer with a tapestry of moments that have been inscribed into what is, initially, a very ordinary-looking street. The compositionally discrete nature of these inscriptions – from the running soldier to the IRA graffiti, the vandalized street lighting and vandal-free placement of the Sinn Fein posters – prevent the single, one-shot, reading. This is a characteristic of all his work, whether it is a celebration of an escape from the H-Block isolation wing of the Maze Prison, in which the form of the Block provides a new and misleading set of markings for a road (*H-Block Prison Protest, Newry,* 1985); or the assertion of Protestant identity, in the form of pavement graffiti of the Battle of the Boyne from which Protestant supremacy in the North decisively dates (*'1688-1690', Antrim,* 1986[19]); or the gestural marking out of Republican territory by the splashes of paint on a country road (*Paint on Road, Gobnascle Estate, Derry,* 1985). Graham does not, however, record these variously loaded and transgressive inscriptions as isolated markings but as fully part of the landscape, a reading of which is problematized by the presentation of this relationship. The landscape holds history as much as it holds the present.

Following the publication of *Troubled Land* Graham continued to return to Northern Ireland, but the photographs that went to make up *In Umbra Res* and which were also included in *New Europe* (1993) show a marked change in approach.

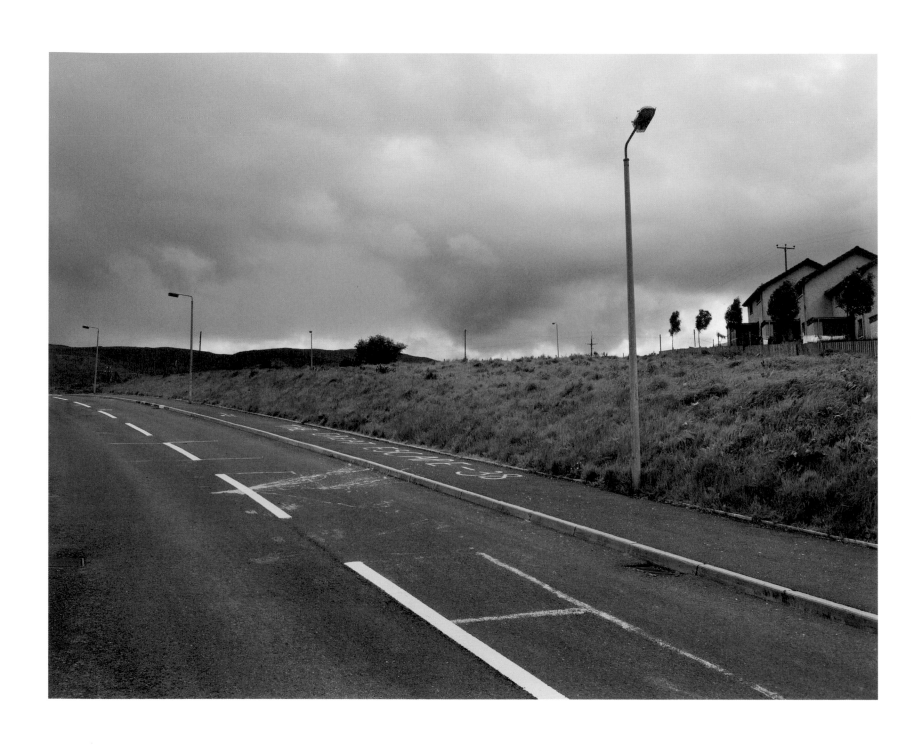

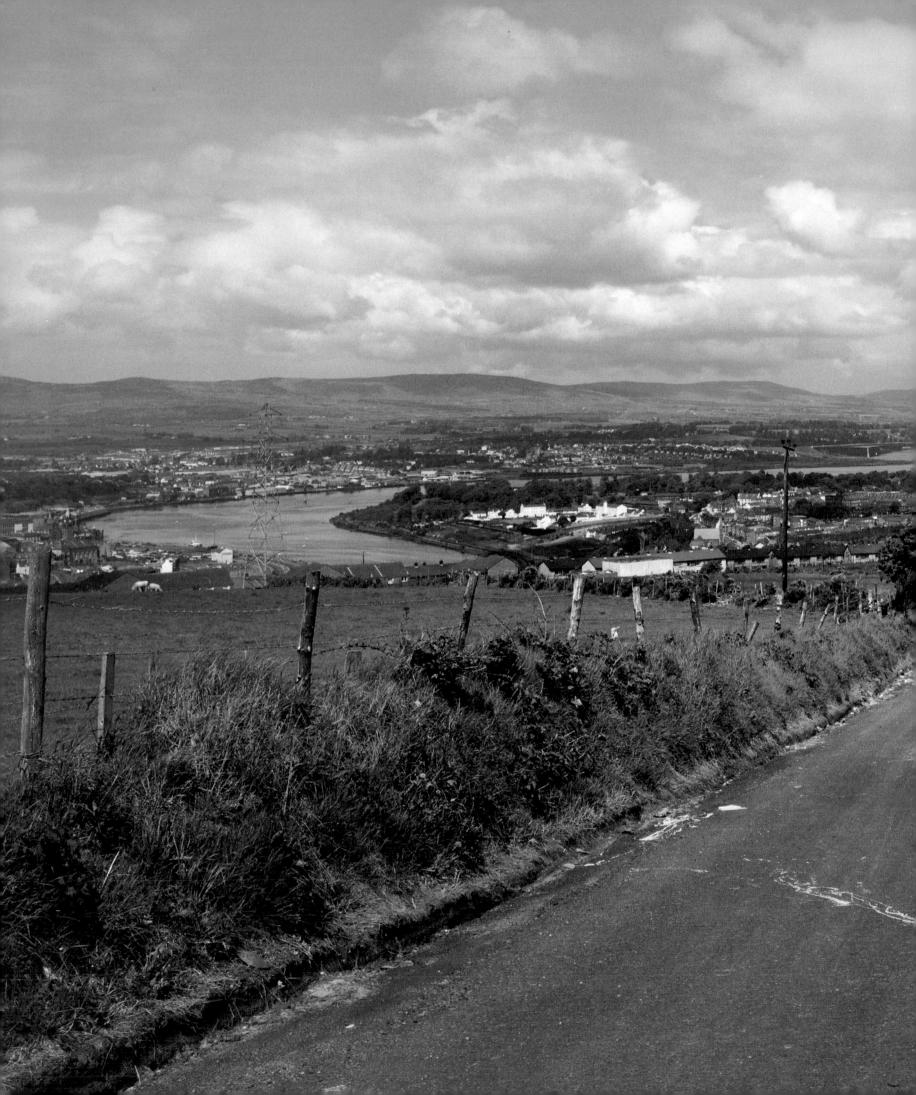

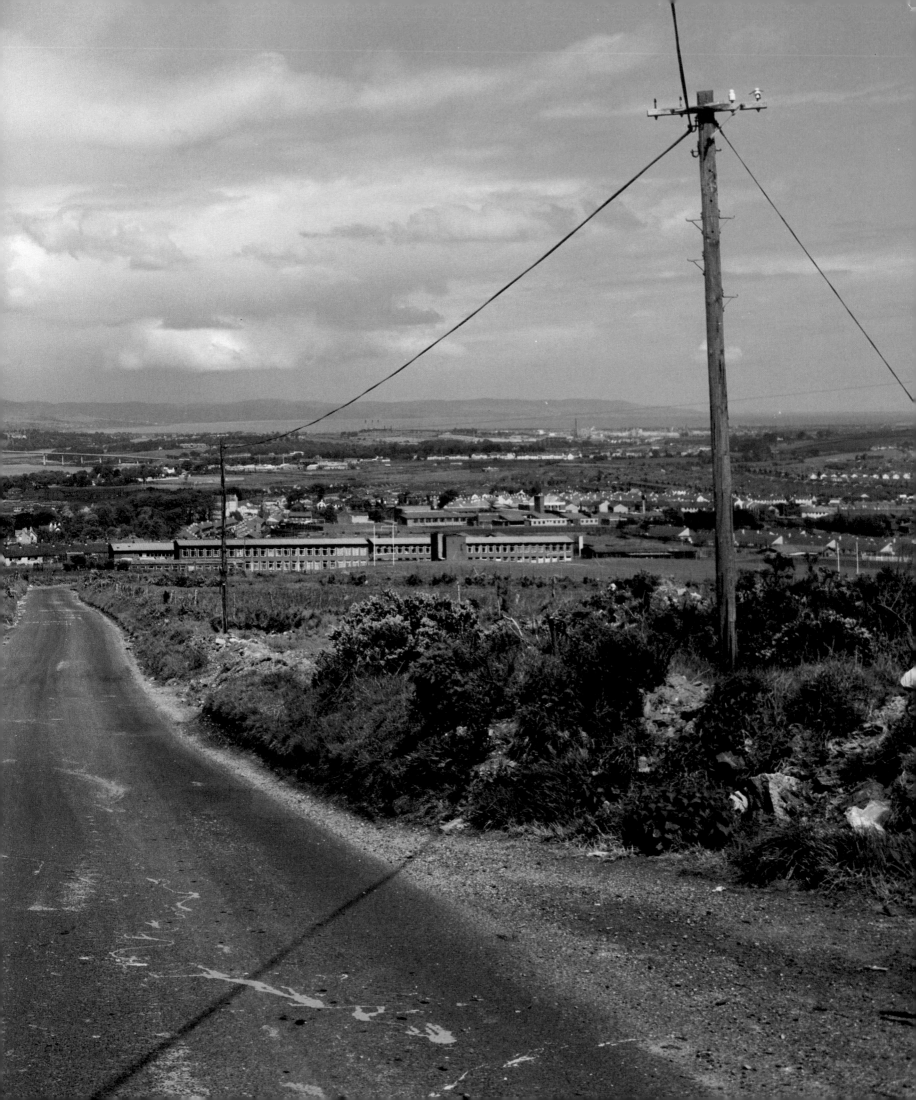

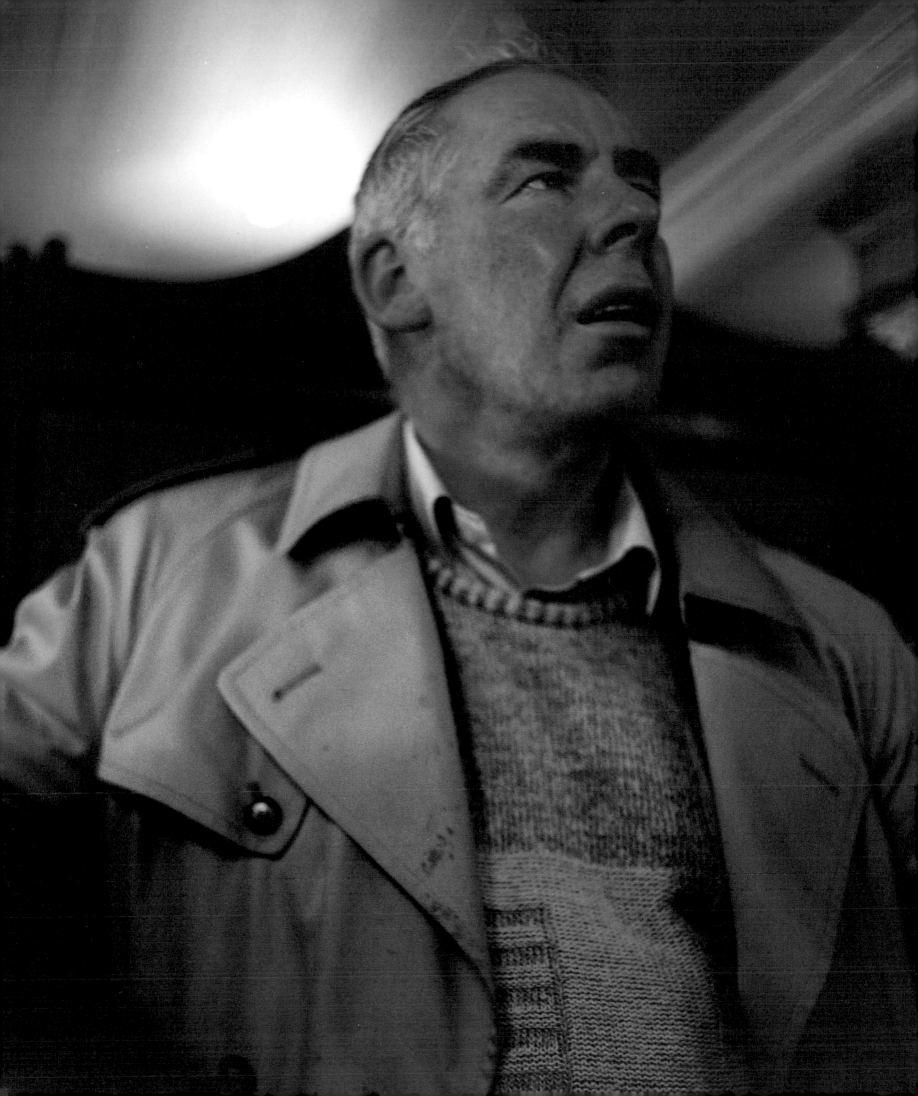

Man Watching TV News
Broadcast of Lynching, Belfast
1988
Colour photograph
152 × 114 cm

In these later works Graham presents images that might provide an allusive symbolism to the conflict. Although he has moved away from the multi-faceted and fragmentary landscape of *Troubled Land,* his experimentation with the diptych and triptych format operate in a similar way by forming a type of interior, narrative conversation. More significantly, with his abandonment of the landscape panorama, the images become rougher and more focused on the human victims of this abject conflict through his consistent use of the close-up. One way of understanding Graham's intention here would be to compare his photograph *Man Watching TV News Broadcast of Lynching, Belfast,* 1988, with a newspaper photograph of the actual event.

The sequence of newspaper photographs shows two soldiers trapped in the middle of a Republican funeral, dragged from their car and murdered. The photographs are matter-of-fact in their depiction of the sequence of moments leading up to their death. Horror is compounded not only by the act of murder but by the fact that it was witnessed by cameras that dared not intervene. However, in dispassionately reporting the incident these photographs can do little to explain it. Graham has instead captured the moment of the recognition of horror, so that where the newspaper offers (and has to offer) literal effect in the guise of reportage, Graham presents an allusive affect. He becomes caught up, complicit even, in the act of that man's looking. There is nothing overtly shocking in the image, but the urgency with which the photograph has been taken is reflected by the palpable sense

'Army Corporal gets out of his car on the Andersonstown Road, Belfast', from *The Sunday Times*, **London, 20 March 1988**

in which this man has been so obviously wounded by the atrocity that he has seen. Although an atrocity such as this can barely be explained, Graham's image provides evidence of thought that reflects as much on a generalized condition of existence as it does on actual events.

With *In Umbra Res,* Graham's view of history shifted, from the all-encompassing landscape of *Troubled Land*, to focus not on the 'incident' but on the effect the incident of history has on the individual (as opposed to the group in *Beyond Caring*) and how that history can be understood through their example. To the photojournalist such an approach would seem insignificant, but Graham's interest has always been in the metaphorical charge that an image might occupy rather than an achievement of illustrative

Untitled, Belfast, 1988 (wire on post)
1988
Colour photograph
152 × 114 cm

Untitled, Belfast, 1988
(woman smoking a cigarette)
1988
Colour photograph
152 × 114 cm

metonymy. The *Television Portraits* which he started while in Japan in 1989 illustrate this point well. As images that might tell a story, they are so inconsequential as to be socially abstract. Although they are casually executed (he has described them as 'snapshots'[20]) their composition is formally considered. Each subject, caught in the act of looking, is held in profile by the camera, their eyes locked elsewhere. These photographs of close friends with their guard down are Graham's most personal photographs. The truths they present to us are so familiar that they can stand no naming, just as the photographs that make up *New Europe* and *Empty Heaven* are defined by a strategy in which disregarded accents are shown to hold a range of historical and metaphorical meanings.

Roland Barthes tells the story that when André Kertesz arrived in America in 1937 the editors of *Time* rejected his photographs because they '"spoke too much"; they made us reflect, suggested a meaning – a different meaning from the literal one. Ultimately, Photography is subversive not when it frightens, repels or even stigmatizes, but when it is *pensive*, when it thinks'.[21] It is in the nature of Graham's photographs that they think rather than just tell. To a photojournalist it might seem perverse to go to Northern Ireland and then photograph the face of a man watching the television news, a gatepost that has been crowned by barbed wire, a woman smoking a cigarette, a wedding photograph shrouded by the shutters of a shop window, or the clouds in an April sky; or to go to East Berlin and photograph dust in the U-Bahn interchange at Friedrichstrasse

Wedding Photograph, Belfast
1988
Colour photograph
114 × 152 cm

John Constable
Dark Cloud Study
1821
Oil on panel
20 × 29 cm

station; or to visit newly-unified Berlin to photograph a post-hole where once the Berlin Wall had been. These images exhibit a lack of interest in the continued power of first impressions in the belief that deeper meanings, and the strong pull exerted by history, move in the shadows behind things, only to reveal their traces, momentarily.

Graham's *Untitled (Cease-fire)* series is an indication of his single-minded conceptual strength of purpose. On 31 March 1994 the I.R.A. announced a 72-hour temporary cessation of hostilities that preceded the full cease-fire in August 1994. Realizing the importance and fragility of the event, Graham went to Northern Ireland in April and, on arriving, he turned his camera not to the streets, landscape or people but onto the sky to create what must be, on the face of it, apparently subjectless photographs.

The particular nature of Graham's project can be better understood when compared with the sky photographs of Stieglitz and Eggleston, or the paintings of Constable. Although it has been proved that Constable's cloud studies of 1821-22 are metereologically accurate, Constable declared that their ambition went far beyond the diaristic recording of the weather. In a letter of the period he wrote that the sky 'must and always shall with me make an effectual part of the composition. It will be difficult to name a class of Landscape, in which the sky is not the "*key note*", the *standard of "Scale*", and the chief "*Organ of sentiment*"... The sky is the "source of light" in nature – and governs everything'.[22] The point of paintings like *Dark Cloud Study* was that they should be scientifically accurate and true, express feeling

and, most importantly, be unnoticed when used within the context of landscape compositions. On the other hand, Eggleston's photographs *Wedgwood Blue,* 1979, in capturing the light at the sky's zenith, the furthest point from the horizon, turn the ordinary into something that might be fully emotive of the extraordinary, and suggest his submission to Yeats' 'cloths of heaven, enrought with golden and silver light' that forms the epigraph to the series' portfolio. In distinction to this approach, Stieglitz in his *Equivalents* used clouds to show 'Objective Truth' and 'Pure Form'. *Equivalent,* 1930, is at one and the same time a factual 'verification'[23] of the clouds, and an abstract, even artificial, construction that mirrors Stieglitz's own subjective emotional state: 'My cloud photographs are equivalents of my most profound life experience, my basic philosophy of life',[24] he claimed.

Although Paul Graham's cloud photographs carry elements of all three of these bodies of work their main intention is quite distinct from them. At a time of an uncertain and fragile peace Graham turned to the sky as the only part of the Irish landscape not touched by the history and scars of 'the Troubles'. The unsettled climactic conditions found in these April skies reflect the fragility of this first cease-fire, but the intention is not just to provide such a straightforward metaphorical charge. Photographs like *Andersonstown, Belfast, Cease-fire April*, 1994, do not stand as a disinterestedly formalist device or within some personal metaphysical schema. As images of that unfocusable concealment that haunts the landscape of Northern Ireland and betrays the seeming

following pages, **Andersonstown, Belfast, Cease-fire April 1994**
1994
Colour photograph
112 × 142.5 cm

**Shankill, Belfast, Cease-fire
April 1994**
1994
Colour photograph
112 × 142.5 cm

**Bogside, Derry, Cease-fire April
1994**
1994
Colour photograph
112 × 142.5 cm

Craigavon, Cease-fire April 1994
1994
Colour photograph
112 × 142.5 cm

difficulty of finding a solution to the conflict, they are as specific as they could be. In this respect these photographs indicate – or in a Barthian sense 'think' – a state of fact, rather than merely exist as expressive metaphorical surrogates. Given their captions, these photographs prove that no part of the landscape, however removed, can actually be detached from the history of Northern Ireland.

During the fabrication of *In Umbra Res* images that stand in the shadow of Irish history – Graham was also turning his camera to the broader European canvas in his pursuit of the 'thinking' photograph, in which an 'objective' photographic facticity is destabilized by the stain of history and the multivalent nature of the signs from which our contemporary environment is constructed. The ideal of a federalist *New Europe*, founded on monetary union, was originally the focus of this work which sought to give another perspective to the orgy of consumption that characterized the

1980s. But, within a couple of years this focus on a Capitalist feeding frenzy shifted to a much more direct treatment of European history. With the collapse of the Iron Curtain and the dismantling of the Berlin Wall in November 1989, the idea of unity shifted so that it became the verification of a crusade. In December 1989, after the Malta Summit, following the initial collapse of much of the Warsaw Pact and the dismantling of the Berlin Wall, President Bush felt justified in declaring that the Cold War was over, that Western democratic Capitalism had triumphed over Communist total-itarianism and that he stood 'at the crossroads of history on the way to a Europe whole and free'.[25] The previous month the *Independent* newspaper had carried a headline stating that 'Hitler's Europe finally crashes to destruction'.[26]

Graham's photographs suggest that the fall of the Berlin Wall was not quite as clear-cut as these statements might suggest. With the demise of Communism, Capital became another exemplar of straining to map out boundaries. After the Berlin Wall was breached on November 9, 1989, East Berliners were each presented with 100 Deutsch marks as *begrüssungsgeld* (greetings money): a means of welcoming them into the Capitalist world of consumer durables. To a degree the boundaries of the present Germany were formed by this *begrüssungsgeld*, in which the collapse of the Berlin Wall signalled the freedom to indulge in a shopping spree (however limited) and the psychological and actual inequalities it identified. The effect of Capital, the death of the Socialist ideal in Eastern Germany, and the legacy of a European history – the death of Archduke

Installation, **'New Europe'**, Anthony Reynolds Gallery, London, 1990

Untitled, 1990 (hole from Berlin wall; swarm of flies)
1990
Colour photographs
diptych, 152 × 114 cm each
Collection, European Parliament,
Brussels

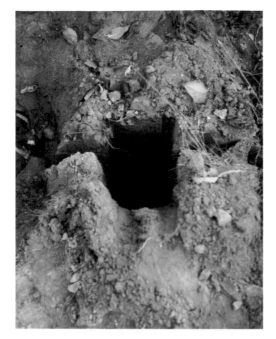

Francis Ferdinand in Sarajevo, the Versailles Treaty, the march of Fascism, the Holocaust, a reconstructed but divided Europe, the promise of a federalist community – conspire to create a powerfully inter-woven matrix in Graham's photographs in which meaning is projected between State and the Individual.

That we live in history's shadow, a shadow that can never be fully erased, is one of the messages contained within the work that makes up *New Europe. Untitled 1989 (Hofbräuhaus man, Munich; erased Hitler; stain remover)* sits full-square within this matrix. The image of Hitler from an educational panel at the Anne Frank house in Amsterdam might be obliterated and so transfigured, but tourists and Nazi sympathizers still continue to leave their mark at one of the sites of Hitler's Beer Hall Putsch. (The all-too visible rise of neo-Nazi Fascists has closely accompanied the road to German re-unification and the fragmentation of Eastern Europe.) Blood and milk can never be properly washed away as if it had never been spilt, leaving its purity in question. However, the literal nature of such a reading of this triptych, or of any of the work in *New Europe*, does not tell the full story. The shadow of history in these photographs is not faceless but falls over each individual. The web that is cast – between a man mainlining heroin, a train coupling at Drancy and a shelf of toy cattle wagons; spit on the Generalissimo's grave and a smiling woman – presents another shadow: one of concealed wounds and escape, internalized and barely articulated. An angry flight from reality. The national boundaries within Europe are endorsed

through this imagery of abjection in which Graham presents the individual as not so much the subject of a greater system (Capitalism or Communism) but as an agent through which a psychological image of the changing face of Europe can emerge and be tracked and read.

Faced by the fall of Eastern Communism, Graham does not turn his camera on the Berlin Wall to find an illustrative iconography. Instead the Wall is presented as a chimera, as a mould that has broken away; at one and the same time branding what it once contained while projecting, through its disappearance, a disfigured identity akin to schizophrenia. The Wall is represented by an empty post hole and a swarm of flies. It can be found in the flame of the 'torch for unity' that burned as long as the Wall stood as a division between what had become two quite separate countries; through two men dancing at a party to celebrate the first anniversary of the Wall's collapse and in an image of property, *lebensraum*, whose painted window frames evoke another road to Calvary. The enactment of such a narrative in *Untitled 1988-90 (torch of unity; unity dance;*

Untitled, Spain, 1988 (spit on Franco's grave; laughing woman)
1988
Colour photographs
diptych, 152 × 114 cm each
Collection, Fotomuseum
Winterthur

**Untitled, Berlin, 1988-90
(torch of unity; unity dance;
house front at night)**
1988-90
Colour photographs
triptych, 75 × 100 cm each

house front at night), between remembrance
and celebration, is not accidental. Graham's use
of the paired or grouped format, like that of the
devotional triptych, enables the telling of a story
by providing a framework for the viewer's sub-
jective readings of the work. The way in which
Lincoln Kirstein had introduced Walker Evans'
American Photographs in 1938 – 'Looked at in
sequence they are overwhelming in their exhaus-
tiveness of detail, their poetry of contrast, and, for
those who wish to see it, their moral implication'[27]
– could stand equally well for Graham's work. This
applies not only to those that used paired or
grouped images but also to the cumulative effect
of his earlier work that was collected in book
format. However, Graham does not rely on typical
iconographic and symbolic structures but instead
on an allusive imagery whose meaning here is
constructed as much from the connections each
panel sets up as from the isolated picture. The
resulting combinatory image is formed through
connections as well as the pictured and actual loss

of boundaries, in which identity can be hidden
or re-fashioned. History is realized as being
as much an act of covering the present as it is
itself covered and hidden over by the present;
a movement, backwards and forwards that de-
stabilizes the picturing of a reality rather than
massaging a dominant reading (such as that
found, by necessity, in most news photographs).

*Untitled 1989-90 (dust, Friedrichstrasse,
Berlin; man on bed; straw in concrete)* emphasizes
the extent to which Graham conceives of documen-
tary photography as a form of visual poetics rather
than the single-minded pursuit of illustrative truth
that is sought by the photojournalist. However,
this poetics is not achieved by an aestheticization
of life's grim realities. Photography's fetishization
of technique and process is discarded in favour of
a directness that serves to heighten the degree to
which the subject of Graham's work is so veiled and
hidden. No longer presented in frames and behind
window mounts, the photographs that make up
New Europe are simply mounted on flat supports

**Untitled, 1989
(man in discotheque, Berlin)**
1989
Colour photograph
100 × 75 cm

**Untitled, Germany, 1989
(man shielding eyes; Star of
David; woman in discotheque)**
1989
Colour photographs
triptych, left panel 100 × 75 cm;
centre panel 203 × 152 cm; right
panel 50 × 38 cm
Collection, Jewish Museum, New
York

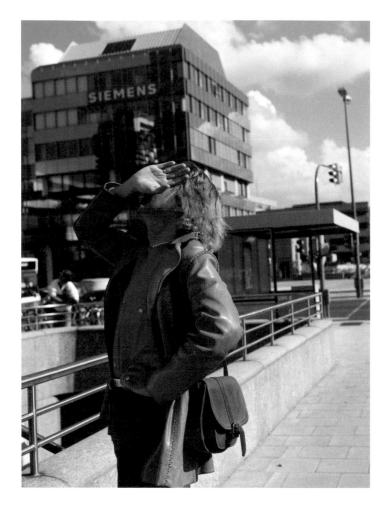

and float just off the wall. The images themselves, often lacking in edge-to-edge sharpness, give the appearance of having been taken with great urgency. The seemingly casual composition suggested in *Beyond Caring* and *Troubled Land* has here been fully realized. *New Europe* is composed and formed not through the action of the Grand Narrative, but by the unnamed and incidental details that somehow pick away at hidden myths and history. The dust at Friedrichstrasse station – an interchange station between the U-Bahn and the S-Bahn – happens to be the only part of East Berlin that one could visit without a visa. The dust was the only tangible visual clue to the creation of this historically-determined no-man's land.

The nameless man, lying lethargically on a bed, surrounded by the bright colours of the Western freedom to consume without question, a television channel-zapper at his side, embodies the ideal of the Western Capitalist dream through the mindless inactivity of the couch potato. The right-hand panel of this triptych returns to the unformed brutalist ground, in which straw, in a dream of urban development, becomes a part of the concrete building blocks of society.

The strength of this work resides, in part, in the directness of its juxtaposition – in a similar way to that in which *Untitled Germany 1989 (man shielding eyes; Star of David; woman in discotheque)* articulates a narrative play of the

Untitled, 1989-90
(dust, Friedrichstrasse, Berlin;
man on bed; straw in concrete)
1989-90
Colour photographs
triptych, left panel 58 × 75 cm;
centre panel 75 × 100 cm;
right panel 58 × 75 cm

hidden, the remembered and the wish to forget and escape. But there is another level of play here, within the very nature of the imagery used, and it is one that Graham has extended further in *Empty Heaven*. In a discussion of some stills from Sergei Eisenstein's films *Ivan the Terrible* and *The Battleship Potemkin,* Barthes describes three levels of meaning: the 'informational', the 'symbolic' and one other, the 'third meaning'[28] that is 'evident, erratic and obstinate' in exceeding 'the copy of the referential motif, it compels an interrogative reading ... neither can it be conflated with ... dramatic meaning'.[29] Where the other two meanings are direct, clear and obvious, the action of this 'third meaning' is 'obtuse'[30] in opening up

the field of meaning into other areas.

Graham's concern with history continues in *Empty Heaven* by tracing how recent history has been largely wrapped-up and covered over by contemporary Japanese culture. In *New Europe* the obtuse meaning was tracked through traces, boundaries, linkages and formless images of the abject – dust, spittle, flies, a hole in the ground, straw mixed in with concrete blocks – that are close to Bataille's irreducible notion of the *informe*.[31] In *Empty Heaven* history has been treated in a different way, and the 'obtuse' meaning takes another character. Contemporary Japan, as it is shown in these photographs, is a place founded on the mask, the wrapping, the

Wrapped Tree # 1, Financial
District, Tokyo; Curl # 1, Subway,
Tokyo
1992-95
Colour photographs
diptych, 105 × 79 cm each
Collection, Kunstmuseum,
Wolfsburg

package and the fold. Into the fold has been
slipped the wound of history, covered by the happy
smile and a healing expanse of saccharine pink.

Writing about a Japan which was both
imaginary and real, Barthes concentrated on
what it meant to wrap. Where 'every object, every
gesture, even the most free, the most mobile,
seems *framed*'.[32] Where, inside that wrapping or
package, there was just an emptiness; as if the
gesture, the act of packing, was expression and
meaning enough. By comparison he also described
the haiku form as occupying a 'breach of meaning'
as well as embodying a counter-descriptive
'exemption from meaning' by its concern in
apprehending the 'thing as event and not as
substance' and ultimately as something that
'happens to language rather than to the subject'.[33]
Looking at two stills from an Eisenstein film,
Barthes had concentrated on the way a woman's
hair is tied up in a bun, 'that the top of a head
(the most obtuse part of the human person), that
a single bun of hair can be the expression of grief
… The whole of the obtuse meaning (its disruptive
force) is staked on the excessive mass of hair'.[34]
The emptiness of the act of tying-up hair functions

as a disruption of representable meaning while
also producing another meaning which passes
through emotion and is pinned-back by an event.

In his close-up photographs of the curls on
the heads of young Japanese women (such as in
the diptychs *Artificial Roses in Bell Jar, Tokyo,*
1995; *Curl #3, Tokyo,* 1992; or *Wrapped Tree #1,*
Financial District, Tokyo, 1995; *Curl #1, Subway,*
Tokyo, 1992) and in his portraits of women (such
as *Mariko, Tokyo,* 1989 or *Girl with White Face,*
Tokyo, 1992) the gestures – a curl of hair, the hand
going up to the face – are in themselves empty,
but by wrapping an emptiness they are pregnant
with a meaning that 'can be seen as an accent,
the very form of an emergence, of a fold (a crease
even) marking the heavy layer of information
and significations … anaphoric gesture without
significant content'.[35] It was by this fold that the
act is 'signed'[36] and given meaning as an event
in which the act of packaging or framing is not
necessarily 'to protect in space but to postpone
in time'.[37] It is this anaphorism, this repetitive
wish to cover and shroud, and the making of what
are precisely elegant yet essentially meaningless
gestures that provides one key to understanding

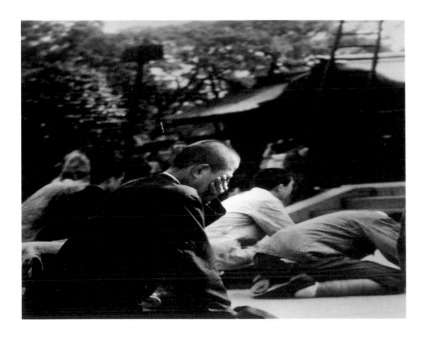

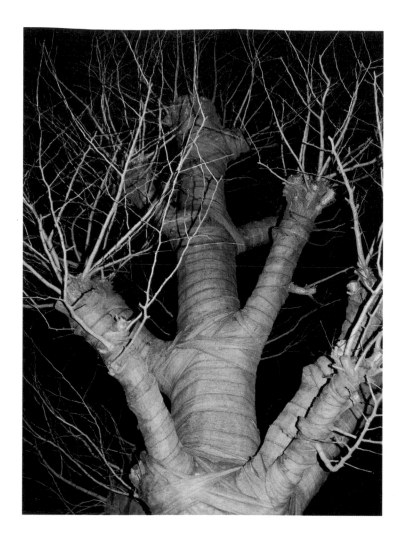

Graham's picturing of Japanese attitudes to the recent past.

The framing of gesture and package provides a useful point of recognition for understanding how history is treated in contemporary Japan. The package not only postpones time just as history itself has been postponed, but it also desubjectifies the role history has in defining the present. As a result of the package, any significant figuration is either removed, sublimated or simply covered over. Although Barthes ends his book on Japan with the words that 'there is nothing to *grasp*',[38] this is perhaps a point that *Empty Heaven* challenges. By recognizing and presenting the ungraspable nature of the Japanese package, the loss of subject that is caught within Graham's 'thinking' photographs is replaced not by meaning, but by the making of meaning as a capturing of the event of language. It is in this recognition afforded by Graham's photographs that history can take its place within the field of signification of the contemporary Japanese landscape.

Diptychs, such as *Atomic Cloud Photograph, Hiroshima; Cat Calendar, Tokyo,* 1989 or *Surrender Photograph, Tokyo,* 1990; *Printed Pink #2, Tokyo,* 1992, project a jarring clash between a horror of the past and that collective cheerful inanity which has replaced it as a saccharine pink glow. These juxtapositions might be brutal, but by magnifying the gap between a history that has been covered

Surrender Photograph, Tokyo;
Printed Pink, Tokyo
1990-92
Colour photographs
diptych, 79 × 105 cm each

right
top, l. to r., **Izumi, Tokyo**
1995
Colour photograph
105 × 80 cm

Girl in Bar, Tokyo
1995
Colour photograph
105 × 80 cm

bottom, l. to r., **Naoko, Tokyo**
1989
Colour photograph
105 × 80 cm

Yuki, Tokyo
1992
Colour photograph
105 × 80 cm

opposite, **Noriko, Tokyo**
1995
Colour photograph
105 × 80 cm

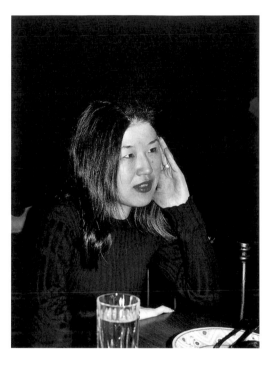

Man # 5, Kasumigaseki, Tokyo;
Man # 6, Kasumigaseki, Tokyo;
Toyota Engine # 3 (Aristo),
Tokyo; Man # 7, Kasumigaseki,
Tokyo; Man # 8, Kasumigaseki,
Tokyo
1995
Colour photographs
4 outside panels 105 × 79 cm
each; centre panel 105 × 140 cm
Collection, Kunstmuseum,
Wolfsburg

over by a contemporary fantasy, Graham reveals as much about the past as the present. The fantasy image in *Candy Wrapper, Tokyo; Kimono Flash Burn Photograph, Hiroshima,* 1989 has been wrapped around history, replacing the destruction of Japanese tradition and pride with an innocent, almost childlike dream world. The magic wand has cured history by making such images as *Kimono Flash Burn Photograph* vanish. By showing these juxtapositions, Graham allows sense to be made not only of history but also of how and why it has been covered over; how a calendar photograph of

four fluffy kittens, a sheet of pink wrapping paper or a sweet wrapper could, by forgetting history, also bind its wounds, and become determining iconic images for contemporary Japanese culture. Furthermore, by bonding these images in a diptych, both the branded body and the healing sweet wrapper come to occupy the same surface, the same skin.

Just as Graham has observed how cartoons form an escapist blanket over the Japanese psyche, so that even Emperor Hirohito sports a Mickey Mouse watch,[39] Japanese society is

characterized by an hermetic conformity that can itself form a vacuum of emptiness. A strong cast of anonymous untouchability spreads across the Japanese political and cultural power base, masking it from sight. It is a rigidly paternalistic society that is run more by unseen businessmen and bureaucrats than by politicians who are accountable to the people. These salarymen dress and look alike and their power is effortlessly disguised. In *Man #5, Kasumigaseki, Tokyo; Man #6, Kasumigaseki, Tokyo; Toyota Engine #3 (Aristo), Tokyo; Man #7, Kasumigaseki, Tokyo;*

Man #8, Kasumigaseki, Tokyo, 1995 they frame the car engine in a metaphor for a power that is both hidden and obvious. The men are photographed in profile, in an intense close-up that makes them faceless and yet also offers the only chance of seeing, without looking through their glasses, directly into their eyes.

With his portraits of Japanese women Graham provides the other side of the paternalistic coin, a feminine conformity to an image of 'happiness, pleasantry, politeness and beauty'.[40] Even so, with these straightforward portraits, aggressively lit by

direct flash, Barthes' presentation of a society in which masking is intensely woven into the fabric of the Japanese subconscious is reinforced. *Yuko, Tokyo,* 1992 sits at the table with her left hand folded over her right, a scarf is tied around her neck and to her side, and opposite an unfinished meal, stands a rack of folded table napkins. She looks down, submissively averting her eyes from the camera. As a person she is as hidden and as wrapped as the anonymous salarymen or the bureaucrats working in Kasumigaseki. The photograph is focused on her folded hands, a sign of Japanese humility that is ruptured by the knuckle-duster ring prominently worn on the forefinger of her left hand and the fact that she is pictured in an Indian curry restaurant in Tokyo. Behind her bowed head is cast a halo shadow over an Indian picture of mythical endeavour and, at the table, traditional chopsticks have been replaced by fork and spoon.

Such slippages occur throughout Graham's photographs. Coming out of the documentary tradition he has used the photographic record – an objective representation of outward visual appearances, a means of obtaining veracity and truth – as a way to delve beneath the surface and obtain hidden truth. Truth that is unpresentable and out of sight, caught between the gaps that exist between life as we know and experience it and those forces that form and have formed our life. Ultimately what these photographs show, and what they are constructed from, is not something seen but that which is invisible: an iconography of thought as a response to history.

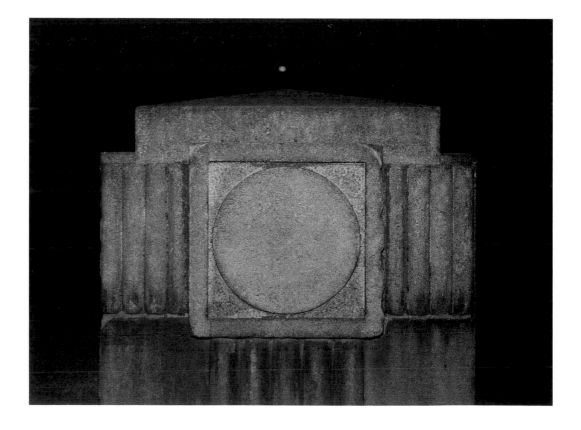

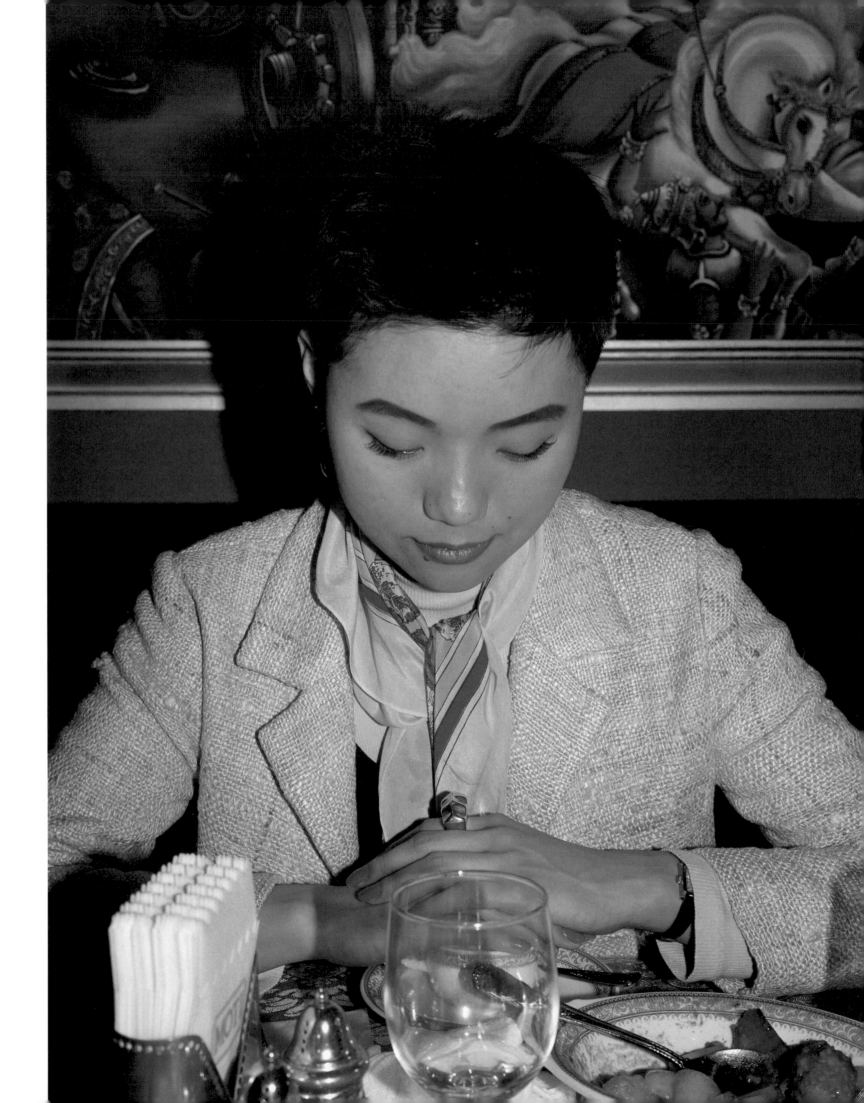

1 Uta Grosenick, 'The Emperor's Watch, an interview with Paul Graham'
 in *Paul Graham: Empty Heaven – Photographs from Japan 1989-1995,*
 Kunstmuseum, Wolfsburg; Scalo, Zurich, 1995, n.p.

2 Walter Benjamin, 'Theses on the Philosophy of History', *Illuminations,*
 Fontana, London, 1982, p. 263

3 See especially Lyotard's writings on the sublime and Postmodernism,
 most notably *The Postmodern Condition: A Report on Knowledge,*
 Manchester University Press, 1984, and also the essays collected in
 his *The Inhuman, Reflections on Time,* Polity Press, Cambridge, 1991

4 In conversation with William Stott, Walker Evans volunteered that
 'I do have a weakness for the disadvantaged, for poor people, but I'm
 suspicious of it. I have to be, because that should not be the motive
 for artistic or aesthetic action. If it is, your work is either sentimental
 or motivated toward "improving society". I don't believe an artist
 should do that with his work'. Cited in William Stott, *Documentary
 Expression and Thirties America,* University of Chicago Press,
 1986, p. 320

5 William Hagan, 'An Interview with William Eggleston', *Aperture* No
 115, New York, Summer, 1989, p. 77

6 Paul Bonaventura, 'Paul Graham, The Man With The Moving Camera,
 interview', *Artefactum* No 51, Antwerp, March 1, 1994, p. 6

7 William Jenkins, 'Introduction', *The New Topographics, Photographs
 of a Man-Altered Landscape,* International Museum of Photography
 at George Eastman House, Rochester, New York, 1975, p. 7

8 Ibid., p. 5

9 For the original layout of Dan Graham's 'Homes for America' (1966)
 see Dan Graham, *Rock My Religion, Writings and Art Projects 1965-
 1990,* MIT Press, Cambridge (Massachusetts), 1993, pp. 14-23. This
 also reproduces a number of Dan Graham's photographs from 1968.

10 William Jenkins, op. cit., p. 5, discusses the nature of the passive frame
 so that 'rather than the picture having been created by the frame,
 there is a sense of the frame having been laid on an existing scene
 without inerpreting it very much'. This notion is discussed further in
 Sally Eauclaire, *The New Color Photography*, Abbeville Press, New York,
 1981, pp. 133-34, in the context of the work of Lewis Baltz.

11 Ian Nairn, *Counter-Attack, Against Subtopia,* Architectural Press,
 London, 1957, p. 356. Nairn was not against the structures and
 appearance of the urban environment as such. His attack was
 launched against the blurring of the different environments, a
 state of affairs that the proliferating road networks encouraged.
 Nairn's aim was to define the 'basic division between types of
 environment and to suggest a framework for keeping each true
 to itself and distinct from its neighbours ... to maintain – or regain –
 the unity of the place'.

12 John Barrell, *The Idea of Landscape and the Sense of Place,*
 Cambridge University Press, 1972, p. 5

13 Paul Graham, 'Statement', in *Britain in 1984,* ed. Paul Barker,
 The Photographers' Gallery, London, 1984

14 Herbie Knott's photograph was reproduced on the *Independent,*
 London, August 15, 1989, p. 1. See also Herbie Knott, 'Coming on
 strong for the camera', the *Independent,* London, August 16, 1989,
 p. 13. Two days later it was reported that a German freelance
 photographer, Nick Vogle, had been arrested during a Belfast riot,
 his car holding 'a rifle magazine, flares, thunderflashes, containers
 of petrol and knives', David McKittrick, 'Photographer expected to
 appear in Belfast Court', the *Independent,* London, August 17,
 1989, p. 1. The following day a letter was published from seven
 photographers (John Arthur, Paul Faith, Paul Lowe, Andrew Moore,
 David Rose, Jeremy Selwyn, Sean Smith) who had appeared in
 Knott's photograph, 'Troubles on Film' the *Independent,* London,
 August 18, 1989, p. 21: 'Twenty years of violence brought 100
 photographers from around the world to Belfast on Monday. They
 were there *because* of this history, they did not cause it'.

15 Jerry Saltz, 'The Scene of the Crime: Paul Graham's *Republican
 Parade, Stabane, 1986*', *Arts Magazine*, New York, January, 1989, p. 14

16 One of the most critical reviews in this vein was Trisha Ziff,
 'Troublesome Photographs', *Aperture* No 113, New York, Winter, 1988,
 pp. 72-73. In this she suggested that it was 'the photojournalist's
 obligation to inform his or her audience of what he sees, thinks and
 feels. Photojournalists have the responsibility to act as purveyors of

both information and understanding, albeit subjective … The work is about Paul Graham, not Ireland'.

17 For a detailed interpretation of Constable's landscape paintings see John Barrell, *The Dark Side of the Landscape, the Rural Poor in English Painting 1730-1840,* Cambridge University Press, 1980, pp. 131-164. Barrell concludes that 'the human significance of Constable's pictures … is not simply what they cannot help divulging about the rural life in 1810 or 1820, but also what they choose to tell us; not simply, then, that Constable reduces all labourers to serfs, but that in the very same act he presents them as involved in an enviable, and almost a relaxed relationship with the natural world, which allowed his nineteenth-century admirers … to ignore the fact that the basis of social harmony is social division'.

18 Roland Barthes, *Camera Lucida,* Vintage, London, 1993, p. 41

19 In 1688 James II, having alienated the English Parliament and the majority of his subjects, fled to France where he received the protection of his cousin Louis XIV. James's daughter Princess Mary, with her husband William of Orange, was offered the throne at the invitation of an alliance of Tories and Whigs. On 7 December 1688 thirteen apprentice boys closed the gates of Derry against the regiment raised by the Catholic Lord Antrim sent by Richard Talbot, Earl Tyrconnell, to re-garrison the town. James was urged by Louis to regain his throne and in March 1689 arrived in Ireland, Tyrconnell having succeeded in disarming the Protestants in Dublin and the South of the country, and laid siege to Derry until 31 July. After having sent an army to Ireland in August, William joined it the following year, reaching Ulster on 14 June 1690 and, on 1 July 1690, defeated James's army at the Battle of the Boyne.

20 Paul Bonaventura, op. cit., p. 11

21 Roland Barthes, op. cit., p. 38

22 Letter from John Constable to John Fisher, in *John Constable's Correspondence: VI: The Fishers,* ed. R.P. Beckett, Ipswich, 1968, pp. 76-77

23 In 1913 Marius de Zayas had declared that 'Photography is not Art. It is not even an art. Art is the expression of the conception of an idea. Photography is the plastic verification of fact'. This sentiment was followed by Stieglitz throughout his career. See Marius de Zayas, 'Photography', *Camerawork* No 41, January, 1913, p. 17

24 Dorothy Norman, *Alfred Stieglitz: An American Seer,* Aperture Inc, New York, 1973, p. 144

25 President Bush on his arrival in Brussels to brief the NATO allies, December 3, 1989, reported in *The Times,* London, December 4, 1989, p. 1

26 Neil Ascherson, in the *Independent,* London, November 11, 1989, p. 1

27 Lincoln Kirstein, 'Photographs of America: Walker Evans', *Walker Evans, American Photographs,* Museum of Modern Art, New York, 1938 [1962], p. 192

28 Roland Barthes, 'The Third Meaning, Research Notes on some Eisenstein Stills', *Image Music Text,* Fontana Press, London, 1977, pp. 52-68

29 Ibid., p. 53

30 Ibid., p. 54

31 See Georges Bataille, *Visions of Excess, Selected Writings, 1927-1939,* University of Minnesota Press, Minneapolis, 1986, pp. 20-23 and 31 Also Rosalind E. Krauss, *The Optical Unconscious,* The MIT Press, Cambridge (Massachusetts), 1993, pp. 165-172.

32 Roland Barthes, *The Empire of Signs,* Hill and Wang, New York, 1994, p. 43

33 Ibid., pp. 69-84

34 Roland Barthes, 'The Third Meaning', op. cit., p. 58

35 Ibid., p. 62

36 Roland Barthes, *The Empire of Signs,* op. cit., p. 45, describes the package as 'geometric, rigorously drawn, and yet always signed somewhere with an asymmetrical fold or knot'.

37 Ibid., p. 46

38 Ibid., p. 110

39 Uta Grosenick, op. cit.

40 James Roberts, 'History Pictures, Paul Graham Interviewed', *Frieze* No 4, London, April-May 1992, p. 44

Artificial Roses in Bell Jar
1995
Colour photograph
57 × 43 cm

Contents

Untitled, 1989 (Hofbräuhaus
man, Munich)
1989
Colour photograph
triptych, left panel 100 × 75 cm

In his photographs of the *New Europe*, Paul Graham presents a vision of Europe as both superficially placid and darkly banal, with turbulence and anger simmering beneath a surface of false walls and cigarette-burned countertops. For many photographers these fugitive moods and passive indicators would hardly constitute a desirable subject for inquiry.

But unlike traditional documentary photographers and photojournalists, who make revealing images by waiting for the unusual, dramatic event to rupture the continuum of the mundane, Graham eschews the picturesque clichés of obvious social dysfunction. He looks for what is generally manifested only in fleeting attitudes, private fears and cryptic gestures, finding visual indications of what is studiously kept out of sight. He often locates meaning within seemingly inconsequential forms, like the crumbling bricks under a Belfast skip or the coupling on a French train. Or graffiti, a motif that repeatedly appears in his work. Graham shows how graffiti sketches out feelings of boredom, confusion, helplessness and hostility, economical signifiers of the crisis of Europe today.

Relatively artless inscriptions can be seen in the backgrounds of images Graham took in English welfare offices in 1984 and 1985, where the clients scrawl personal sentiments ('Up Yours Ugly!') or political ones ('Ulster Volunteer Force') in barren rooms mostly graced with bureaucratic directives ('Do Not Call at Reception, Your Name Will Be Called'). In the slightly later Northern Ireland work, the graffiti takes on a bitter urgency that literally permeates the landscape. It assumes a number of forms, as political acronyms (IRA, UVF), posters and symbolically coloured paint — the green, white and gold of the republicans or the red, white and blue of the unionists, displayed in neat rectangles or passionate splatters — which mark buildings, public signs, curbstones, streets and nature itself.

By definition, the landscapes and cityscapes required a wide, encompassing view, in which Graham stood back to show how partisan paint blotches on a Belfast house, for instance, became an integrated part of the social landscape. But Graham considerably narrowed his focus for his series *New Europe*. Photographing from 1988 to 1992 in nine countries — Germany, England, France, Italy, Spain, Belgium, Switzerland and Holland as well as Northern Ireland — he moved in close. He looked at a baby eating, a woman smoking, a square hole left in the ground after the Berlin wall was dismantled. He also found more graffiti, on a public telephone table in Belfast, a painted steel girder in Berlin and an exhibited photographic reproduction in Amsterdam. As it has at other points in his work,

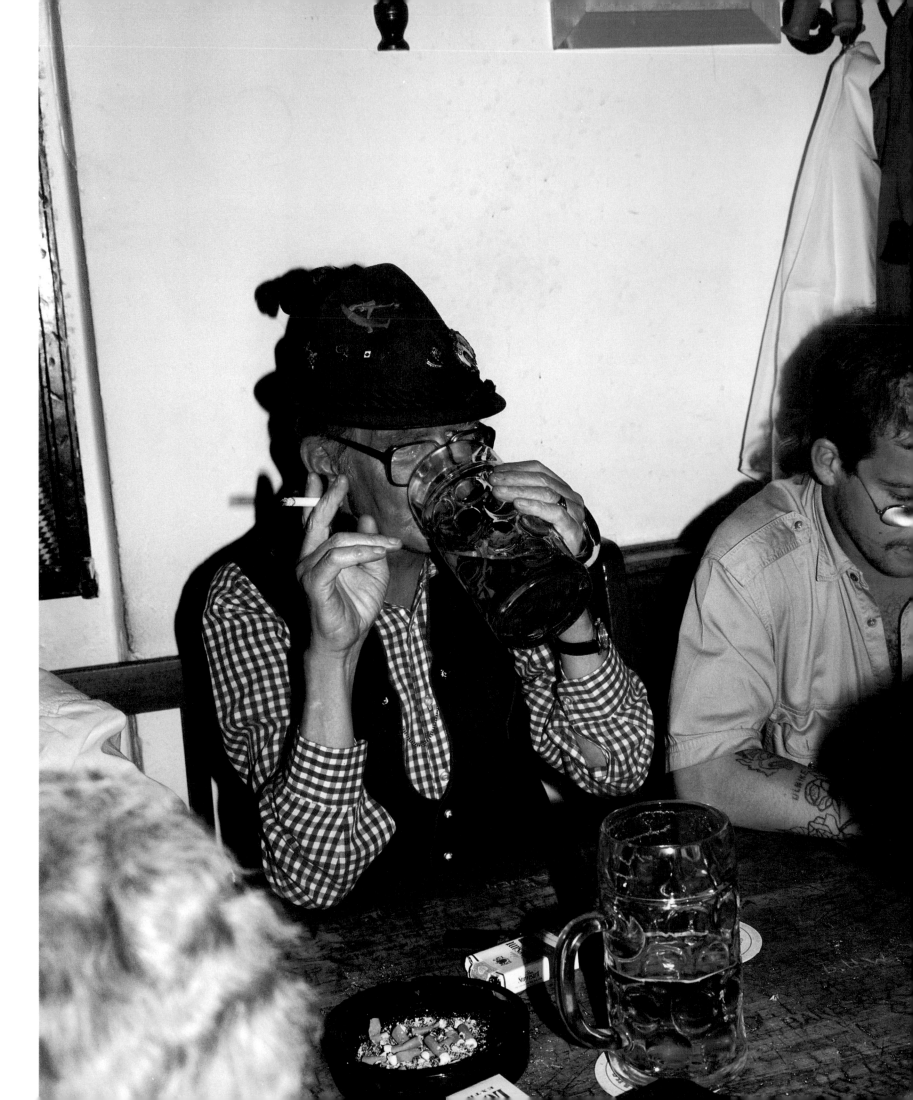

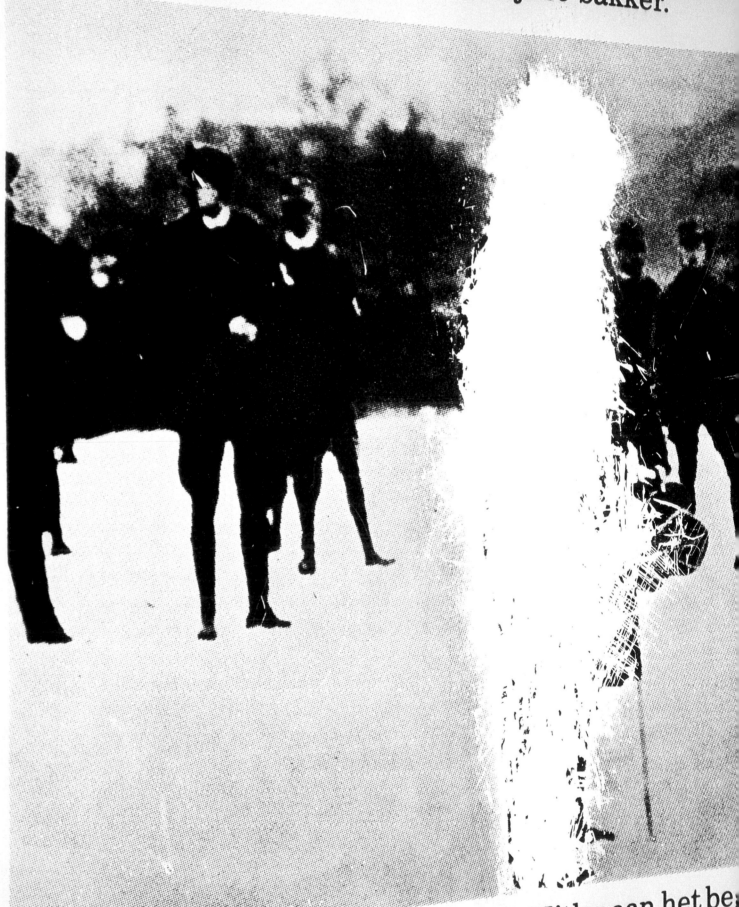

Adolf Hitler aan het be[...]
van zijn politieke carriè[...]
[...]kt hij nog

The inflation led to hoarding and food short- ages: a long line lin baker's.

Adolf Hitler at the be- ginning of his political career. Here, still in civil-

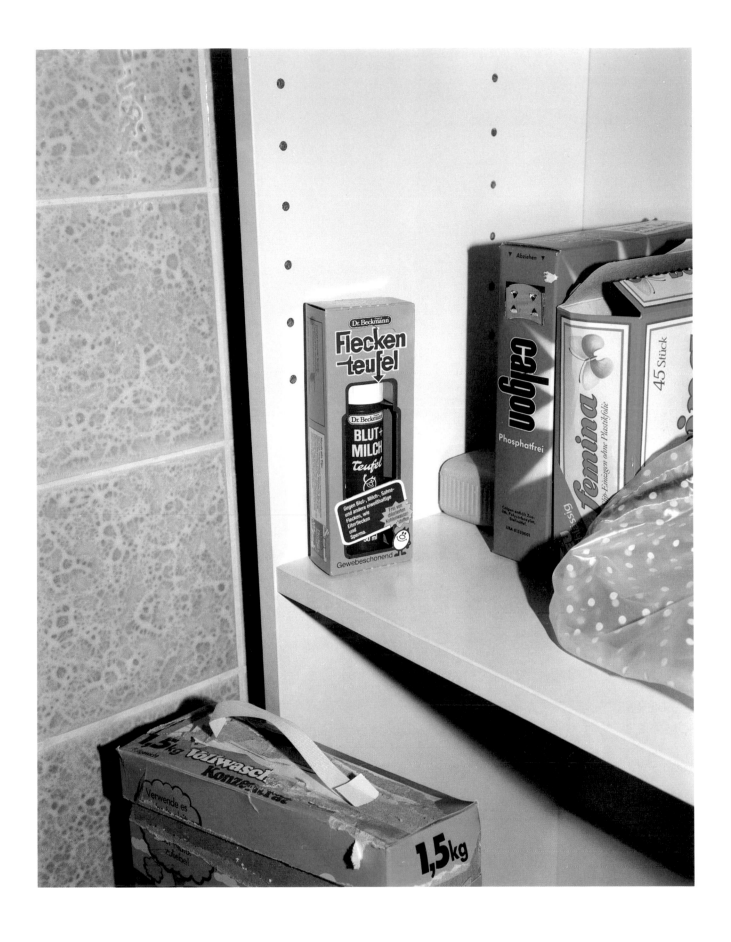

Untitled, 1989 (stain remover)
1989
Colour photograph
triptych, right panel 50 × 38 cm

graffiti indicates for Graham a subconscious archive of historical and political stresses that still resonate and shape the present.

Yet the graffiti Graham finds is often ambiguously elementary. One triptych, *Untitled, 1989 (Hofbräuhaus man, Munich; erased Hitler; stain-remover)*, has at its centre a photographic reproduction showing a defaced image of Hitler. What the viewer sees is the white shape of a figure that has been stubbornly and almost completely scratched out. Only a featureless negative form remains, with some details of shoes and a hat still intact around its edges. A partially visible caption written in Dutch and English identifies the absent figure as 'Adolf Hitler at the beginning of his political career', attired in civilian clothes and addressing some associates. Like all graffiti, this demands attention and interpretation.

But how can a bald negation be deciphered? The exact motive for the obliteration is unknown to us, whether it was righteous or self-righteous, whether it was made by one of Hitler's victims (which seems unlikely) or by an enraged student of history. It seems to operate on the magical, delusory belief that by erasing the image the social pathology it represents would also be eradicated. Or that some protest would be lodged that would affect the future, ensuring that such a monstrous figure could never rise again.

Oddly, this proposes that meaning resides in seeing something, or rather in 'reading' the visible antipathy to a photograph of Hitler that the anonymous author feels. Whatever its message and whomever its author, the act of 'removing' Hitler swings the spotlight from him, the perpetrator of a massive modern horror, and trains it on the anonymous scribe, scratching away at history. Demolishing the image is posited as a noble gesture, a disavowal on a grand scale, with the anti-author rushing in as hero.

Graffiti is a common form of populist speech, practised across cultures and across time, from ancient Pompeii to contemporary America. It comes in a familiar variety of forms and sizes, from tiny pictographs and single words to the gigantic, painted stylizations created by urban graffiti writers on subway trains, buildings and highway overpasses in the US and other countries. Since the 1970s, that type of 'signature' writing, in which the author's name or 'tag' comprises the major part of the design, has been the most visible and most publicized kind of graffiti. In the US it is produced mainly by black and Latino youth, for whom it addresses issues of identity, status, territoriality and intergroup communication.

The interpretation of graffiti types has been undertaken by psychologists, sociologists, ethnographers, pop culture theorists and an occasional art historian, who study its sexual, political, racial, psychological, philosophical, humourous or aesthetic content.[1] It is often considered a defacement, with the large-scale tagging of subway cars in New York treated by some city officials as criminal behaviour to be fought and eradicated. But no attention has been paid to graffiti that simply eradicates what already exists without replacing it with an alternative message. This author, at any rate, was not able to find any such studies of graffiti. What really arouses attention and reaction is the graphic assertion of private identity or opinion on public territory.

The nullification that Graham finds in the eradicated Hitler hasn't got the power to provoke the spectator's ire. Rather, it seems to nourish amnesia on the subject of Hitler, giving a negative visible form to the opinion that enough has already been communicated about the Nazi era and that it should be forgotten, should literally be wiped out. This theme of disavowal is recapitulated by Graham throughout the triptych.

In its right-hand image he locates the desire for erasure at the level of the mundane, in a package containing a stain remover, Dr. Beckmann's 'Stain-Devil' *(Flecken-teufel)*, which sits on a household shelf in Munich. The package's text claims that the product eliminates blood, milk and other troublesome substances while being 'safe for fabrics' *(gewebeschonend)*. The 'devil' here is a good imp who can help wash the blood away without harming what it stains. A doctor's name on the preparation gives it the imprimateur of authority and goodness. Yet, in the context Graham supplies, it also recalls bad doctors like Josef Mengele, who furthered Nazi policies that eliminated troublesome elements of the population who were supposedly a 'stain'. This good imp promises an answer to the 'good' German citizen who is tired of accounting for the mess of history — use his product and clean it all away. Otherwise what Germans are left with will be irrevocably besmirched and ruined.

Perhaps the older man in the third image of the triptych is one of those weary 'good' Germans. Certainly, he proclaims an unrepentantly German identity, dressed in traditional garb and downing a stein of beer while he smokes a cigarette. But how innocent his visit and identification is can be called into question: he is sitting in the Hofbrauhaus, an infamous Munich beer-hall known as the place where Hitler held early political meetings during his rise to power. As befits such a site, unknown scribblers have left their marks in the tabletop

Helen Levitt
New York *c.* 1940
c. 1940
Black and white photograph
24.7 × 33 cm

at which the man sits. It's difficult to read what they have written, although mostly it seems to be names and initials. This seems harmless enough, except that the infamous history of the place is so well-known that these visitors must want to link their monikers to that monstrous lineage. Then the graffiti takes on another, more ominous cast, as entries in a log-book of hatred that military and ideological triumph was supposed to have closed, although its legacy is one that can't be erased.

A number of photographers have looked at graffiti, finding it a form of folk art, native wisdom or safety valve for ordinary people's thoughts. In the 1940s in New York, Helen Levitt recorded chalk drawings, playful observations ('Button to Secret Passage, Press') and rude comments ('Olga is a stinker very much'), drawing attention to a quality of naiveté and innocence in marks probably made by children. About the same time, Aaron Siskind found graceful abstract patterns in the signs posted or painted on public buildings, framing fragments of them to create compositions that embraced the aesthetic of post-war abstract expressionist painting. Lee Friedlander in the 1970s and 1980s made images showing single words ('Pain', 'Revolt'), political mottos ('Stop the Right') and fantasies ('I was once a beautiful model'). What their images of graffiti have in common is the expression of a certain poignancy and humanity, the unedited outpouring of the authors' private frailties and desires.

In contrast, the graffiti Graham finds is dark and troubled, evidence of the human psyche pushed to the edge. He seems to propose that this is how mute frustration, anger and incomprehension is manifested while it is still under control, before it explodes into riot, mayhem and ethnic 'cleansing'. Assuming that his viewers understand the stakes, he asks for an imaginative engagement on their part.

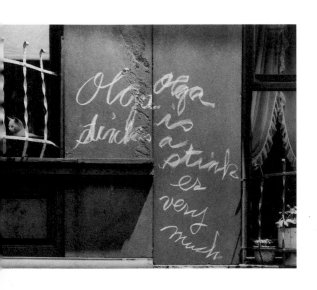

Graham's images are so visually simple that they sometimes seem to repel rather than invite scrutiny; the viewer seemingly 'gets' the image in an instant. But in fact, his photos take time to see, not so much in order to decipher the image itself as to comprehend its implicit meaning. They also require a willingness to think and to reflect, rather than providing the purely retinal gratification or emotional manipulation of so much photography. To him, neither photography nor contemporary reality offers such indulgent satisfactions.

Untitled, 1989 (Hofbräuhaus man, Munich; erased Hitler; stain remover)
1989
Colour photographs
triptych, left panel 100 × 75 cm; centre panel 152 × 203 cm; right panel 50 × 38 cm

1. Some of the most thoughtful texts on graffiti are: Tricia Rose, *Black Noise: Rap Music and Black Culture in Contemporary America*, Wesleyan University Press, Hanover, New Hampshire, 1994, pp. 41-47; Kirk Varnedoe and Adam Gopnik, *High & Low: Modern Art and Popular Culture*, Museum of Modern Art, New York, 1990, pp. 69-99. This volume also has a good bibliography on graffiti; Susan Stewart, 'Ceci Tuera Cela: Graffiti as Crime and Art', in *Life After Postmodernism: Essays on Value and Culture,* ed. John Fekete, St. Martin's Press, New York, 1987, pp. 161-180; Waln K. Brown, 'Graffiti, Identity and the Delinquent Gang', *International Journal of Offender Therapy and Comparative Criminology* No 22, 1978, pp. 46-48.

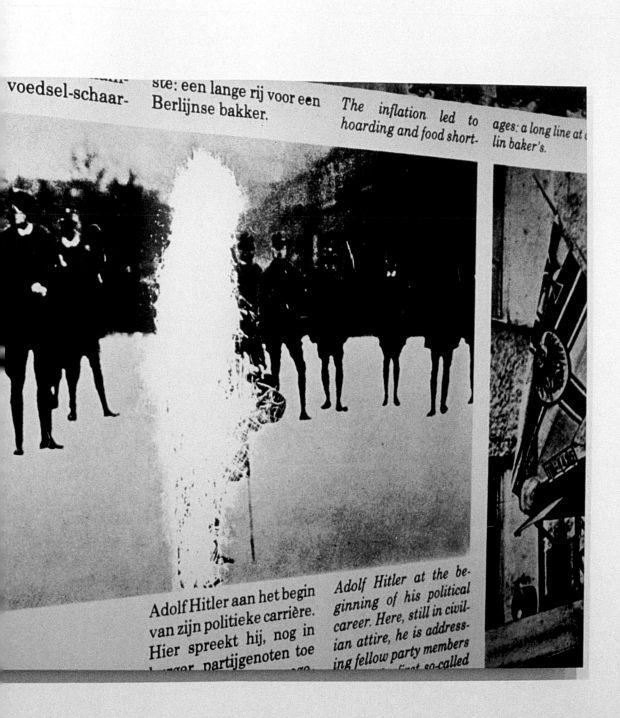

voedsel-schaar-ste: een lange rij voor een Berlijnse bakker.

The inflation led to hoarding and food short-ages: a long line at ... lin baker's.

Adolf Hitler aan het begin van zijn politieke carrière. Hier spreekt hij, nog in ... partijgenoten toe

Adolf Hitler at the be-ginning of his political career. Here, still in civil-ian attire, he is address-ing fellow party members ...

Contents

[...] In the reception room I lit a brazier, and we both sat over it warming our hands. I noticed some snowflakes melting on the overcoat Shintaro was continuing to wear, and asked him:

'The snow has started again?'

'Just a little, Sensei. Nothing like this morning'.

'I'm sorry it's so cold in here. The coldest room in the house, I fear'.

'Not at all, Sensei. My own rooms are far colder'. He smiled happily and rubbed his hands together over the charcoal. 'It's good of you to receive me like this. Sensei has been very good to me over the years. I cannot begin to calculate what you have done for me'.

'Not at all, Shintaro. In fact, I sometimes think I rather neglected you in the old days. So if there's some way I can redeem my negligence, even at this late stage, I'd be pleased to hear of it'. Shintaro laughed and went on rubbing his hands. 'Really, Sensei, you say the most absurd things. I can never begin to calculate

what you have done for me'.

I watched him for a moment, then said: 'So tell me, Shintaro, what is it I can do for you?'

He looked up with a surprised expression, then laughed again.

'Excuse me, Sensei. I was getting so comfortable here, I'd quite forgotten my purpose in coming to trouble you like this'.

He was, he told me, most optimistic about his application to Higashimachi High School; reliable sources gave him to believe it was being viewed with much favour.

'However, Sensei, there appears to be just one or two small points on which the committee seems still a little unsatisfied'.

'Oh?'

'Indeed, Sensei. Perhaps I should be frank. The small points I refer to concern the past'.

Man # 2, Kasumigaseki, Tokyo;
Artificial Cherry Blossom, Tokyo;
Man # 3, Kasumigaseki, Tokyo
1991-95
Colour photographs
triptych, left panel 105 × 79 cm;
centre panel 105 × 140 cm; right
panel 105 × 79 cm

'The past?'

'Indeed, Sensei'. At this point, Shintaro gave a nervous laugh.
Then with an effort, he continued: 'You must know, Sensei, that
my respect for you is of the very highest. I have learnt so much
from Sensei, and I will continue to be proud of our association'.

I nodded and waited for him to go on.

'The fact is, Sensei, I would be most grateful if you would
yourself write to the committee, just to confirm certain
statements I have made'.

'And what sort of statements are these, Shintaro?'
Shintaro gave another giggle, then reached his hands out over
the brazier again.

'It is simply to satisfy the committee, Sensei. Nothing more. You
may recall, Sensei, how we once had cause to disagree. Over the
matter of my work during the China crisis'.

'The China crisis? I'm afraid I don't recall our quarrelling, Shintaro'.

'Forgive me, Sensei, perhaps I exaggerate. It was never as
pronounced a thing as a quarrel. But I did indeed have the
indiscretion to express my disagreement. That is to say, I resisted
your suggestions concerning my work'.

'Forgive me, Shintaro, I don't recall what it is you're referring to'.

'No doubt such a trivial matter would not remain in Sensei's
mind. But as it happens, it is of some importance to me at this
juncture. You may remember better if I remind you of the party
we had that night, the party to celebrate Mr. Ogawa's engage-
ment. It was that same night – I believe we were at the Hamabara
Hotel – I perhaps drank a little too much and had the rudeness to
express my views to you'.

'I have a vague recollection of that night, but I cannot say I
remember it clearly. Still, Shintaro, what has a small disagree-
ment like that to do with anything now?'

Atomic Cloud Photograph,
Hiroshima; Cat Calendar
1989-90
Colour photographs
diptych, 57 × 76 cm each

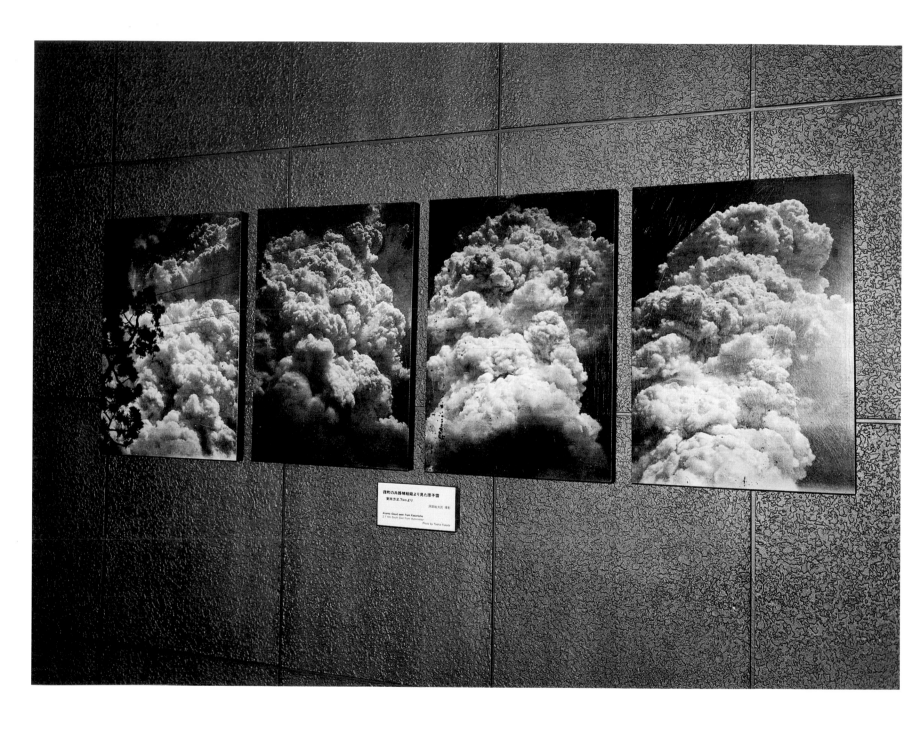

'Forgive me, Sensei, but as it happens, the matter has come to have some significance. The committee is obliged to be reassured of certain things. After all, there are the American authorities to satisfy'. Shintaro trailed off nervously. Then he said: 'I beg you, Sensei, to try and recall that little disagreement. Grateful as I was – and still remain – for the wealth of things I learnt under your supervision, I did not always, in fact, concur with your view. Indeed, I may not be exaggerating to say that I had strong reservations about the direction our school was taking at that time. You may recall, for instance, that despite my eventually following your instructions over the China crisis posters, I had misgivings and indeed went so far as to make my views known to you'.

'The China crisis posters', I said, thinking to myself. 'Yes, I remember your posters now. It was a crucial time for the nation. A time to stop dithering and decide what we wanted. As I recall, you did well and we were all proud of your work.'

'But you will recall, Sensei, I had serious misgivings about the work you wished me to do. If you will recall, I openly expressed my disagreement that evening at the Hamabara Hotel. Forgive me, Sensei, for worrying you with such a trivial matter'.

I suppose I remained silent for some moments. I must have stood up at around this point, for when I next spoke, I recall I was standing across the room from him, over by the veranda screens.

'You wish me to write a letter to your committee', I said eventually, 'disassociating you from my influence. This is what your request amounts to'.

'Nothing of the sort, Sensei. You misunderstand. I am as proud as ever to be associated with your name. It's simply that over the matter of the China poster campaign, if the committee could just be reassured'.

He trailed off again. I slid open a screen just far enough to form a tiny gap. Cold air came blowing into the room, but for some reason this did not concern me. I gazed through the gap, across

the veranda and out into the garden. The snow was falling in slow drifting flakes.

'Shintaro', I said, 'why don't you simply face up to the past? You gained much credit at the time for your poster campaign. Much credit and much praise. The world may now have a different opinion of your work, but there's no need to lie about yourself'.

'Indeed, Sensei', Shintaro said, 'I take your point. But getting back to the matter in hand, I would be most grateful if you would write to the committee concerning the China crisis posters. In fact, I have here with me the name and address of the committee chairman'.

'Shintaro, please listen to me'.

'Sensei, with every respect, I am always very grateful for your advice and learning. But at this moment, I am a man in the midst of my career. It is all very well to reflect and ponder when one is in retirement. But as it happens, I live in a busy world and there are one or two things I must see to if I am to secure this post, which by all other counts is mine already. Sensei, I beg you, please consider my position'.

I did not reply, but continued to look at the snow falling on my garden. Behind me, I could hear Shintaro getting to his feet.

'Here is the name and address, Sensei. I will leave them here. I would be most grateful if you would give the matter due consideration when you have a little time'.

There was a pause while, I suppose, he waited to see if I would turn and allow him to take his leave with some dignity. I went on gazing at my garden. For all its steady fall, the snow had settled only very lightly on the shrubs and branches. Indeed, as I watched, a breeze shook a branch of the maple tree, shaking off most of the snow. Only the stone lantern at the back of the garden has a substantial cap of white on it.

I heard Shintaro excuse himself and leave the room.
[...]

Candy Wrapper, Tokyo; Kimono Flash Burn, Hiroshima
1989-90
Colour photographs
diptych, 76 × 57 cm each
Collection, Tate Gallery, London

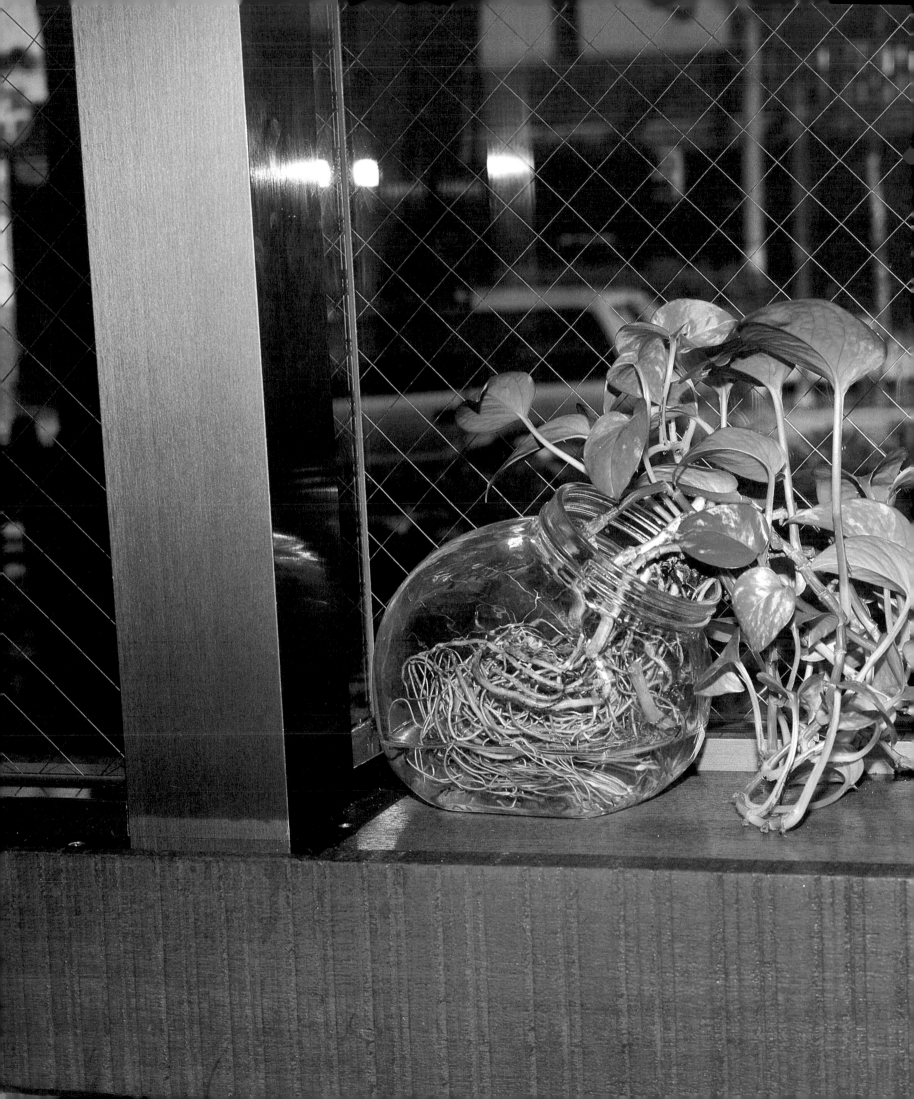

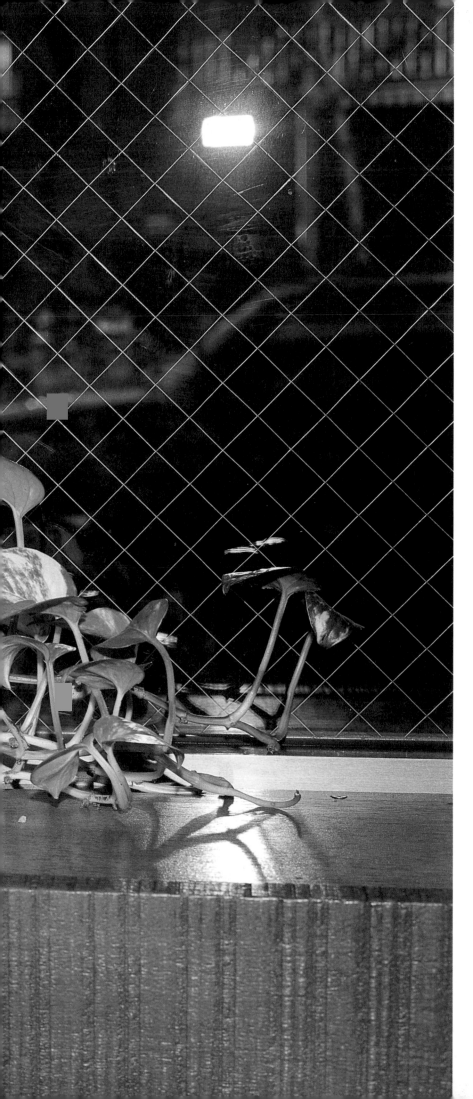

Roots in a Bottle, Tokyo
1992
Colour photograph
79 × 105 cm

Artist's Choice

The Elephant Vanishes (extract), 1993
Haruki Murakami

So that's my life – or my life before I stopped sleeping – each day pretty much a repetition of the one before. I used to keep a diary, but if I forgot for two or three days, I'd lose track of what had happened on which day. Yesterday could have been the day before yesterday, or vice versa. I'd sometimes wonder what kind of life this was. Which is not to say that I found it empty. I was – very simply – amazed. At the lack of demarcation between the days. At the fact that I was part of such a life, a life that had swallowed me up so completely. At the fact that my footprints were being blown away before I even had a chance to turn and look at them.

Whenever I felt like that, I would look at my face in the bathroom mirror – just look at it for fifteen minutes at a time, my mind a total blank. I'd stare at my face purely as a physical object, and gradually it would disconnect from the rest of me, becoming just some thing that happened to exist at the same time as myself. And a realization would come to me: this is happening here and now. It's got nothing to do with footprints.

Reality and I exist simultaneously at this present moment. That's the most important thing.

Translated from the Japanese by Alfred Birnbaum and Jay Rubin

To ~~[illegible]~~ maintain a subdued compliant workforce ~~[illegible]~~ one must employ both positive (coercive) and negative (fear building) tactics. (the sugar & the whip) The coercive aspects in [Vaper?] centre of the concept of a benevolent state, which treats its populace as ~~[illegible]~~ blessed children. Showering them with gifts, assuring them of their own uniqueness, and generally ~~[illegible]~~ rewarding them [the state's love] for their lucky place in paradise.

Contents

above, Installation,
Hypermetropia, Tate Gallery
London, 1996

right, **Hypermetropia**
1995
Panel 1 of 25 colour photographs
86 × 105 cm

following pages, **Hypermetropia**
1995
Panels 2-25 of 25 colour
photographs
86 × 105 cm each

Out on the main road north of my apartment I stopped for lunch in a noodle bar opposite a used car forecourt. The garage, right beside this arterial road, was festooned with pink plastic cherry blossoms everywhere. They were stuck on the lamp stands and posts around the perimeter of the sales area as well as on every possible support inside the lot itself. Each consists of an array of brown plastic tubes as branches, pointing upwards, into which was inserted the 'blossoms' of the most incredible fluorescent pink. These were free to rustle in the wind just like the real blossoms and boughs of trees. Strung out between these points were lines of metallic foil decorations, in gold and silver, to make a cats-cradle canopy above the cars. These were in the form of spinning wheels, that would rotate as the wind blew, and catch the sunlight, sparkling and dazzling, while making an attention-grabbing noise. On most of the posts were bright spotlights, set to play on the cars and decorations, which remained on despite it being a day of brilliant sunshine.

The cars themselves sat under an individual rainbow arch of multi-coloured plastic decorations, free-standing and running from just behind the front wheel, up over the car by some six feet, to come back down by the other wheel. It reminded me of some wedding service where the bride-to-be waits under a garland of flowers. This feeling was increased by the fact that nearly all the cars were white – apparently the favourite 'lucky' colour in Japan. Of course each car had a large fluorescent price sticker in the window in pink or orange.

The sales office, two stories high, and the size of a family house, was made in exaggerated Disneyland style, to look like an overgrown Wendy house, with bright lime-green wood boards and white alpine shutters, with little hearts cut out of every aperture. Of course this too was festooned with pink blossoms. There were no salesmen that I could see, but then again it was just an average midweek lunch time. Music came over the loudspeaker system that covered the lot, with some Japanized western bubble gum pop.

All of this was situated in the far north of Tokyo, well outside of any fashionable district, and away from any commercial area that I could see. Indeed the road was the typical scruffy city rat-run, clogged with cars, trucks and delivery vans. Pedestrians were only able to cross by means of a footbridge, and most hurried off to quieter side streets as soon as possible. Although this was a particularly striking example, there were many similar garages along the road that day, and it seemed quite unexceptional to the average Japanese.

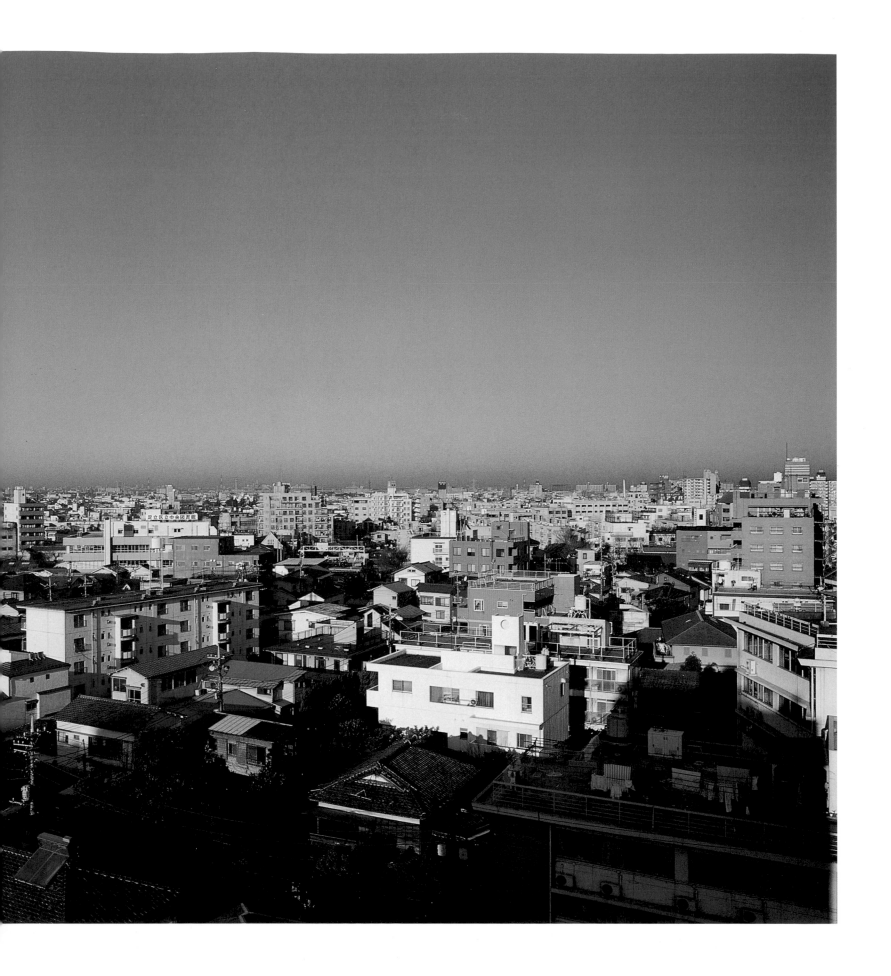

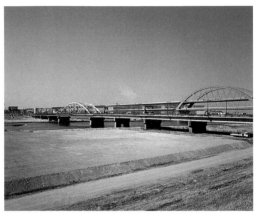

A Conversation with Lewis Baltz 1995

Paul Graham **When we first discussed this talk, we swapped faxes about the situation of the medium now, and you qualified your attitude to photography by paraphrasing Frank Zappa's quote about jazz: 'It isn't dead, it just smells funny'.**

Lewis Baltz I'd also like to come back to that fax because I made some assertions, maybe a little hyperbolic, maybe not, but they connected with my malaise about the state of photography at this moment. It's not dead, but it seems to have exhausted much of what has been defined as its mandate. Any discussions that it was finished gelled during the times of those 150th anniversary shows, where basically the same photographic history was reiterated worldwide. But then again, here we are talking, so perhaps the endgame is the most interesting part.

Graham **Whilst I agree with your malaise, and concur that there are difficulties facing the medium, I disagree that we are in an 'endgame' situation. I think it's much more a case of: 'the king is dead, long live the king'.**

Baltz OK, let me respond to that. I have found some people's work in photography interesting and engaging. I would find it useful to say all the words I don't want to use in order to characterize your work – you know, it's 'straight' photography, it's in the documentary style, but all those words are burdened with pejorative connotations.

Graham **Indeed, as are the labels we attach to the practitioners themselves; are they 'photographers' or 'artists'? Has the burden shifted to artists using photography, rather than photographers using the world?**

Baltz This also comes with another kind of implosion in the art world, I mean, Christ, it could be worse, we could be painters – which is not to say that there is no possibility to make interesting paintings at this moment. But it seems even more problematic than photography, finding itself in a historical situation that is more or less fully negotiated.

Graham **We are getting ahead of ourselves – what is it precisely that you consider the nails in the coffin? What bell tolled the knell? And most importantly, what is it exactly that is dead? Is it not simply that old, innocent photography, what I like to term the 'old consciousness' of the medium that has died? That naive vision of the world as a place with a direct, two-dimensional reality that one could simply record?**

Baltz Dylan Thomas was wrong: after the first death there are many others. Let's take another line through that, the line of material culture. When one reads Braudel, or Ladurie, it's impossible not to remark on the lack of material in the pre-industrial world. Household inventories of a successful peasant family would list a candle, a cooking pot but no spoon, a straw bed, a table but no benches or chairs. Simply there was not very much in the way of artefacts in those days. Not enough to go around. Then, in the nineteenth century, industrialism put paid to that and now we're drowning in our manufactures. Our current crisis seems to be how to find an environmentally neutral way to dispose of all this rubbish. I bring that up because I think we're in the same condition with regard to images. With a similar history, a few centuries ago the church monopolized imagery, and it was literally miraculous. Then imagery became increasingly secularized, first to the aristocracy, then to the new middle classes, and finally, in 'the age of mechanical reproduction', to almost everyone. Satellites beaming thirty images per second on 150 channels, hourly, daily, over every continent except Africa. In view of that, it's a bit difficult to regard an image as something precious. Only in the context of art can images become objects of contemplation, and, of course, commodification. The reaction of the photography establishment to all of these changes has been to circle the wagons and talk to itself. Look at the 'photography' programme of most of the 'leading' museums. Look at MoMA, regurgitating the same issues that were resolved twenty years ago. Meanwhile, with a handful of exceptions, almost everything of interest using photography during those 20 years was made by people who didn't consider themselves – and didn't want to be considered as – photographers. Obviously I think that you're among that handful, which is why I found this chance to speak with you so interesting.

Graham **I have to agree with much of that, yet would insist on the fundamental validity of the medium. Don't misunderstand me, I'm not fighting for 'real' photography, for**

Untitled, 1988 (model soldiers)
1988
Colour photograph
18 × 24 cm

Garry Winogrand
Apollo 11 Moon Shot, Cape
Kennedy, Florida
1969
Black and white photograph

'back to the scriptures' stuff, the decades of *Time* and *Life* passed long ago, and as we all know, stagnation leads to death. But while you're casting around for a new identity, one could argue that the true cul-de-sacs are where one uses the medium as a shallow imitation of another, ignoring the innate qualities it possesses, and trying to force it to perform like a different beast – when it will inevitably look clumsy and leaden.

Baltz We could also say that traditional photography foreclosed its own future by refusing to acknowledge its own mediation of the phenomenal world. In this there is less distance between, say, Robert Frank and Richard Prince than photographers imagine.

Graham **Yes, one could point out literal similarities – Frank re-photographed existing imagery – postcards, political posters, advertisements, etc. – quite extensively, but more importantly his sensibility was no less arbitrary than Prince's. Having said that, it's fascinating how a particular perspective is quickly lost for what is was – a viewpoint – and becomes established as 'the way it was', to the point where certain photo/artists come to possess certain decades. The question of what was there and what was imposed, and how partial this vision may be, is forgotten, and we accept that the 1930s look like Evans, the 1950s like Frank …**

Baltz And these are the images that cinema and television draws upon, closing the circle.

Graham **I don't know so much of the 1960s, but tell me, as an American, does the work of Garry Winogrand come close with its anti-war demonstrations, Apollo launches, Mohammed Ali press conferences, etc.?**

Baltz I'd say it's one truth, and a highly selective one at that. How would you characterize the 1980s?

Graham ***(laughs)* Difficult isn't it? The glass becomes more opaque as one approaches the present. Yet artists can be measured in one way by their ability to see through that opacity. Perhaps some of your works, *Park City* for example, but the problem is how the decades slip, they coalesce, the popular understanding of the 1960s ignores the first half of that decade, and chooses something like 1967-72 as the height of the 1960s ideal.**

Baltz It never divides neatly on the zero.

Graham **The 1980s were strange though, because they did precisely that. It all changed exactly in 1990, when the recession started and people's perspective shifted, fast. But to go back to your question, is the lack of a clear identifiable vision of our time a measure of the medium's failure, its inadequacy to measure up to the situation? I wonder, do you have certain works in mind?**

Baltz For me the 'high 1980s' was the New York zeitgeist, which means Mapplethorpe, although perhaps I'm being parochial. Like it or not, along with Salle, and Schnabel and Longo, Mapplethorpe caught the spirit of that parenthetical decade: the demi-monde, the gay revolution, the AIDS plague, all played against the backdrop of the Reaganite reinforcement of corporate Fascism. But you had something similar in Britain, I believe. Anyway, it was a tough time for visual representation because all the important things went on behind the scenes.

Graham **That was probably part of the answer, this addiction to the surface, when what is going on beneath the surface is the essence. But photography singularly failed to capture this zeitgeist because, by the early 1980s, it was simply stuck, rusted in its long adopted positions.**

Baltz And the ever-present chorus of stupidity that weighs the medium down. Photography as a medium has a confused and incomplete history. We have the opinions of certain historians, critics, with their precepts promoted through books, exhibitions, reviews. As a medium, unlike film or video, it has intrinsic qualities that are not fully exploited. I think that my quarrel is not with the medium itself, but with what has been done with it, what's been written, how we define photography. This history of the medium has been to valorize one particular part of the medium only – documentary style, which certainly exists, and exerts a power. I probably have no great argument with this, but I keep thinking, what if cinema had evolved around those lines, dominated by documentary work, with a little bit of other stuff around the edges ...

Graham **Yes, but we both know that they are deceptively different media, much less related than people imagine. One could argue that they have each gravitated towards their central intrinsic qualities, the core of their power as media, and to deny this quality is to be a flat-earther. In this way, the apparent difference is not so remarkable. That doesn't mean that their are no common points within the media, or within the**

Untitled, Spain, 1988 (coins on shelf)
1988
Colour photograph
203 × 152 cm

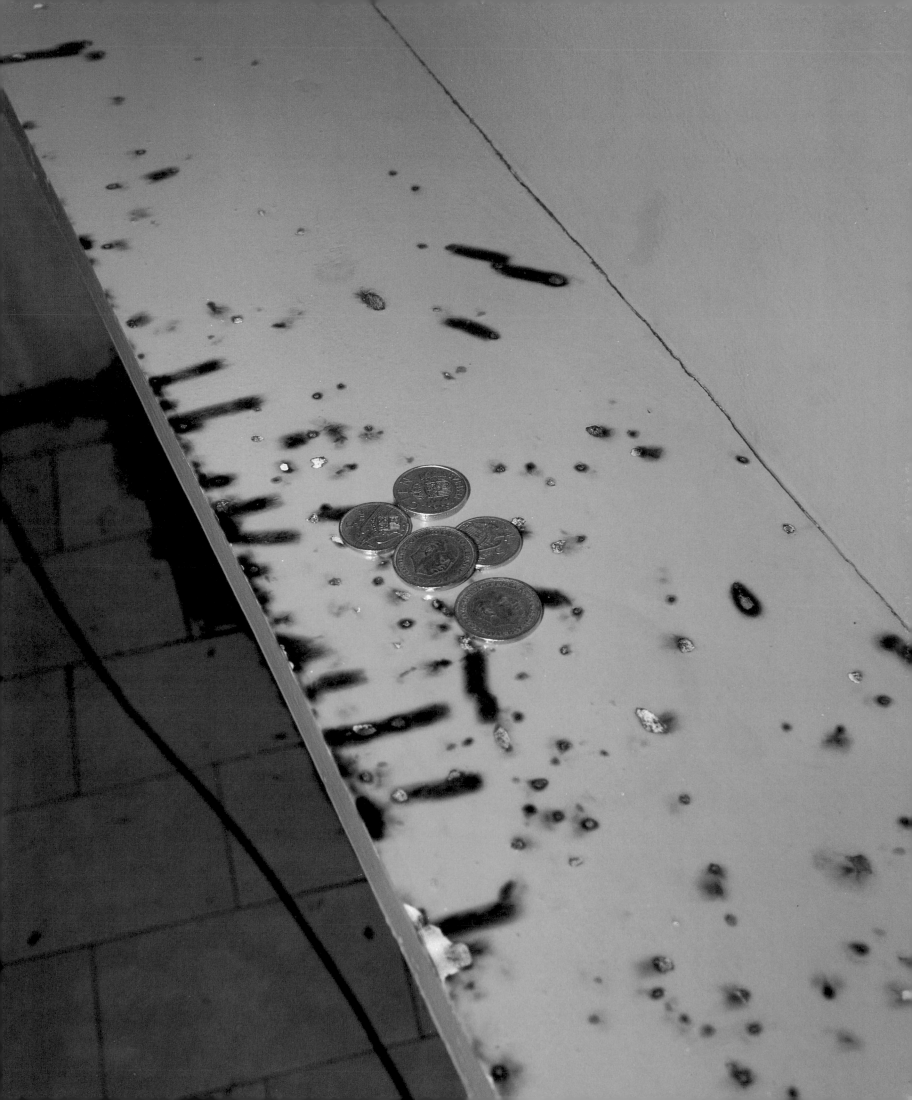

Untitled, 1989 (woman choosing jewellery)
1989
Colour photograph
18 × 24 cm

following pages, **Untitled, Belfast, 1988 (concrete bench)**
1988
Colour photograph
75 × 100 cm

motives/aspirations of the director-artist-photographer that underpin each enterprise.

Baltz Indeed, nevertheless, when I look at *New Europe* I see it as a paper movie. I don't mean to say that your images are no more individually significant than frames in a film, but that their singularities are subsumed in the totality of the work. Anyway, if photography must be justified by its relations with other media, better cinema than painting and its silly idea of 'the masterpiece'.

Graham **Modern literature is not so dissimilar. Photography doesn't restrict itself as much as you imply. Books, and I'm not talking anthologies here, bookworks that aspire to the depth and resonance of literature are an effective and powerful form, a good distribution model. Yet if you discount them as small run productions, of limited specialist interest, then you must discount contemporary literature also, for that has remarkably similar print runs and audiences.**

Baltz True, contemporary literature and more so, poetry, is in the same horrible dilemma: it has no audience. This is the difference with cinema, which has enormous popularity. Photography is a smaller medium in comparison – it is not interesting to all people, and can never contend with cinema's enormous popularity.

Graham **Oh come on, some cinema has this popularity, but most quality cinema, most 'art cinema', plays to a highly selective audience in a ghetto of art film theatres which are every bit as rarefied as the art or literature circuits. It's just that the boundaries are not so clear.**

Baltz How would you say your work is critically positioned within the medium, and does that agree with your own perspective?

Graham **You are perceived completely differently according to the background from which the criticism comes. For example, from within the secular church of art-photography my work of ten or fifteen years ago was seen as somewhat radical, like working in colour when all serious photographers made black and white, like mixing up genres by making war photographs that looked like landscape photographs.**

Baltz I'd forgotten about those canons.

Graham **Exactly, just like the Berlin wall; things seemed permanent, insurmountable, yet when a chink appears, the whole thing dissolves and you can hardly find a trace of it now. Those same canons applied to critiques of your work in the early 1980s, don't you think?**

Baltz The usual criticism of my work was that neither my subjects, nor my means of representing them were 'interesting', which I think derived from a humanist perspective that insisted that interest rested in the obviously dramatic.

Graham **I've always felt uneasy with photographs that rely on some dramatic external event for their 'interest'. But to present the other perspective, that of the broader contemporary art world, my work would seem somewhat conservative, in its appearance at least.**

Baltz How would you react to the assertion that you photographed Europe like a third world country, seething with bitter tribal memories bubbling just below its placid consumerism? I recall a remark by someone, made just after the Berlin wall fell: 'Now Europe is safe for Fascism'. I thought it ridiculous at the moment. Fascism seemed obsolete, discredited in its own terms, the stuff of old World War II movies. I believed that the future would be elsewhere, single market turbo-capitalism, happy European yuppies gorging themselves on Italian fashions, French wines and German cars, the dawn of the age of heroic consumerism.

Graham **The European version of Steiner's 'California promise'.**

Baltz The Balkan war has shown that consumerism and tribal warfare are by no means mutually exclusive. And, without playing the journalist, and without moralizing, you caught that contradiction in *New Europe*.

Graham **At the time of that work, in 1987-88, the triumphalism of Thatcher-Reaganism was near its peak, and was spurred to greater gloating as the wall and Communism collapsed. In the midst of this, the neo-utopians came out with their talk of a united Europe, the single borderless consumer paradise. However, as Steiner again puts it, 'anyone cursed with the cancer of thought can see the shadows at the heart of the carnival'. And so this carnival of a united Europe unshackled from history, freed of that burden, would create a new capitalist superstate where all would prosper if they would**

only believe, and embrace its promises.

Baltz Americans don't live with their past in the same way as Europeans. In fact they hardly live with it at all.

Graham **The uncomfortable past is far removed, away from home soil – Europe, Japan, Korea, Southeast Asia …**

Baltz Yes, but even when the past was brought home, an ugly past, it doesn't have the same import as here. In ex-Yugoslavia, 1387 is a date worth killing and dying for. In France, massive denial notwithstanding, no one has really forgotten World War II, the occupation and, of course, the collaboration. No one's forgotten Algeria. By contrast, in the 1992 presidential elections, Bush attacked Clinton on his anti-Vietnam war activism. The attack failed, not because Americans had come around to the point of view that the war was wrong, but because they simply didn't care – it was just history. Your prescience in *New Europe*, it seems to me, was not so much in predicting a European future as in acknowledging a past that refuses to disappear.

Graham **In itself this comment provokes questions – is it healthy to live with that burden of shadows? Japan has succeeded, or at least partially succeeded, in blotting out its past. Social decisions have been made to live for now and the future. Perhaps those decisions have good motives, but I fear not; often it has more to do with sweeping a discredited memory out of sight so that a hegemonious system can maintain an unquestioned grip on power.**

Baltz Yet in Europe, the capitalist utopian idea is that history can be effaced except as a tourist attraction.

Graham **You know a lot of European integration is not driven by positive dreams of a bright future, but by fear of the alternative, those same alternatives that have failed us before. France is embracing Germany so tightly simply out of fear, it is a last resort to align and integrate itself with German power, avoiding the inevitable conflict that would otherwise lay ahead. Fear is the motivation behind the great European love-in …**

Untitled, Paris, 1988
(man on metro)
1988
Colour photograph
75 × 100 cm

Contents

Chronology Paul Graham Born 1956 in Stafford, England, lives and works in London

Selected exhibitions and projects
1978-86

1978
B.S.c Hons Bristol University

1979
Arnolfini, Bristol (solo)

1980
Ikon Gallery, Birmingham (solo)

1982
Winston Churchill Fellow

'Houses and Homes',
Arnolfini, Bristol; **Institute of Contemporary Arts**,
London (group)

1983
Arts Council Publication Award

Book, *A1 – The Great North Road*, Grey Editions,
London

'A1 – The Great North Road',
The Photographers' Gallery, London, toured to **Stoke
on Trent Museum; King Street Gallery**, Bristol (solo)

1984
'Britain in 1984',
The Photographers' Gallery, London; **National
Museum of Photography**, Bradford
Cat. *Britain in 1984*, The Photographers' Gallery,
London, text Paul Barker

'Strategies – Recent Development in British
Photography',
John Hansard Gallery, Southampton (group)

1985
Greater London Arts Association Visual Arts Award

'Descrittiva',
Musei Comunali, Rimini, Italy

1986
Arts Council Publications Award

Book, *Beyond Caring*, Grey Editions, London

'British Photography',
Houston Foto Fest, Houston (group)

'Beyond Caring',
The Photographers' Gallery, London (solo)

'The New British Document',
Museum of Photography, Chicago (group)

'Beyond Caring',
Brewery Arts Centre, Kendal toured to **Ffotogallery**,
Cardiff; **Axiom**, Cheltenham; **National Museum of
Photography**, Bradford, **Triangle Arts Centre**,
Birmingham (solo)

Watershed Gallery, Bristol (solo)

'Force of Circumstance',
PPOW Gallery, New York (group)

Selected articles and interviews
1978-86

1979
Paley, Maureen, 'Paul Graham', *British Journal of
Photography*, London, August

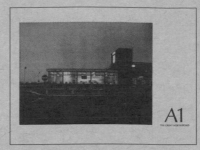

1982

Holborn, Mark, cover and review, *Creative Camera*,
London, October

1983

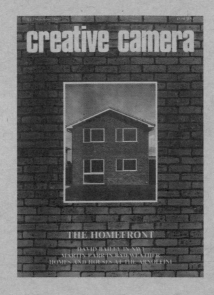

Jeffrey, Ian, *Ten 8*, Birmingham, No 14

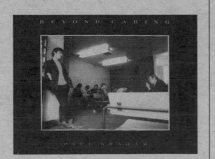

Turner, Peter, Interview with Paul Graham, *Creative
Camera*, London, February

Handy, Ellen, 'Force of Circumstance', *Art in America*,
New York, February

Exhibitions and projects
1987

1987
'Recent Acquisitions',
Victoria and Albert Museum, London (group)

Book, *Troubled Land*, Grey Editions, London

Cornerhouse Arts Centre, Manchester (solo)

Spectrum Gallery, Sprengel Museum, Hanover (group)

Young Photographers Award, **International Center of Photography**, New York

Chapter Arts Centre, Cardiff (solo)

FNAC Les Halles, Paris (solo)

'Attitudes to Ireland',
Orchard Gallery, Derry, Northern Ireland (group)
Brochure, *Attitudes to Ireland*, Orchard Gallery, Derry, Northern Ireland, text Declan McGonagle

'Inscriptions and Inventions: British Photography in the 1980s',
British Council tour to Ghent, Belgium; Brussels; Luxembourg; Liége, France; Charleroi, France; Italy and Germany (group)
Cat. *Inscriptions and Inventions: British Photography in the 1980s*, British Council, text Brett Rogers

'Troisième Triennale',
Musée de la Photographie, Belgium (group)
Cat. *Troisième Triennale*, Musée de la Photographie, Belgium, text Georges Verchaval ed.

'Critical Realism',
Castle Museum, Nottingham, toured to **Edinburgh Arts Centre; Camden Arts Centre; Winchester Art Gallery** (group)
Cat. *Critical Realism*, Castle Museum, Nottingham, text Brandon Taylor ed.

'New British Photography',
Modern Arts Museum, Tampere, Finland (group)

Whitechapel Art Gallery, London (group)

'Corporate Identities',
Cornerhouse Gallery, Manchester (group)
Brochure, *Corporate Identities*, Cornerhouse Gallery, Manchester, text Jérôme Sans

Arles Rencontres, Arles, France (solo)

'Konigreich',
Forum Stadtpark, Graz, Austria (group)
Cat. *Konigreich*, special edition of *Camera Austria Magazine*, text Christine Frisinghelli ed.

'Future of Photography',
Corcoran National Gallery of Art, Washington (group)
Cat. *Future of Photography*, Corcoran National Gallery of Art, Washington, text John Gossage ed.

Selected articles and interviews
1987

1987

Bishop, William, 'Troubled Land', *British Journal of Photography*, London, 8 May
Lothian, Murdoch, 'Small Signs of Civil War', *The Guardian*, London, 28 March

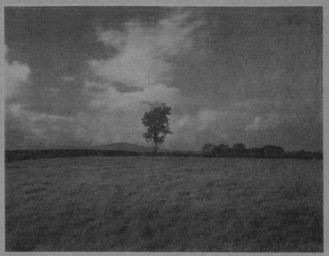

TROUBLED LAND THE SOCIAL LANDSCAPE OF NORTHERN IRELAND

PHOTOGRAPHS BY PAUL GRAHAM

S P E C T R U M

Future of Photography

September 10 — December 13, 1987
The Corcoran Gallery of Art
Washington, D.C.

Helen Chadwick
Paul Graham
Volker Heinze
James Sherwood
Michael Spano
Jim Stone
Bruce Weber

SPECTRUM is supported in part by a grant from
the National Endowment for the Arts.

Exhibitions and projects
1987-89

Kodak Gallery, Tokyo; **Kodak Gallery**, Osaka (solo)

Jones Troyer Gallery, Washington DC (solo)

Stills Gallery, Edinburgh (solo)

'Recent Histories',
Hayward Gallery, London (group)
Cat. *Recent Histories*, Hayward Gallery, London,
text Paul Bonaventura

Channel 4/Arts Council Video Bursary

'New Photography 3',
Museum of Modern Art, New York (group)

'Mysterious Co-incidences',
The Photographers' Gallery, London (group)
Cat. *Mysterious Co-incidences*, The Photographers'
Gallery, London, texts Susan Butler and Stuart Morgan

'Recent Acquisitions',
Museum of Modern Art, New York (group)

Magazine feature, *Camera Asahi*, Tokyo, October

1988
Eugene Smith Memorial Fellowship, USA

'British Landscape',
XYZ Gallery, Ghent, Belgium (group)

'Selected Images',
Riverside Studios, London (group)

Museum Het Princessehof, Leeuwarden,
The Netherlands (solo)

'Third Fotobienal',
Vigo, Spain (group)
Cat. *Third Fotobienal,* Centro de Estudias Fotográficos,
Vigo, Spain, text Manuel Sendon ed.

'A British View',
Museum für Gestaltung, Zurich (group)
Cat. *A British View*, Museum für Gestaltung, Zurich,
text Martin Heller

'Camouflage',
Curt Marcus Gallery, New York (group)

'Towards a Bigger Picture:
British Photography in the 1980s',
Victoria and Albert Museum, London; **Tate Gallery**,
Liverpool (group)
Cat. *Towards a Bigger Picture: British Photography in the
1980s,* special magazine edition, *Aperture*, No 113,
New York, Winter, text Mark Haworth-Booth

PPOW Gallery, New York (solo)

1989
Fellow in Photography, **Museum of Photography**,
Bradford

Selected articles and interviews
1987-89

Grundberg, Andy, 'New Images', *New York Times*, 13
November

1988

Saltz, Jerry, 'Notes on a Photograph', *Arts Magazine*,
New York, January 1989

1989

Exhibitions and projects
1989-90

'The Art of Photography 1839-1989',
Museum of Fine Arts, Houston, toured to **Royal Academy of Art**, London; **Australian National Gallery**, Canberra (group)
Cat. *The Art of Photography 1839-1989*, Museum of Fine Arts, Houston, text David Mellor

Centre Regional de la Photographie, Douchy, France (solo)

'Fotobiennale Enschede 1989',
Enschede, The Netherlands (group)
Cat. *Fotobiennale Enschede 1989*, Enschede, The Netherlands, text Leo Delfgaauw

'Framed',
Artspace, San Francisco (group)

'Hot Spots Curator's Choice IV',
Bronx Museum of the Arts, New York (group)
Cat. *Hot Spots Curator's Choice IV*, Bronx Museum of the Arts, New York, text Laura J. Hoptman

'Through the Looking Glass: Independent Photography in Britain 1946-1989',
Barbican Art Gallery, London, toured to **Manchester City Art Gallery** (group)
Cat. *Through the Looking Glass: Independent Photography in Britain 1946-1989*, Barbican Art Gallery, London, texts John Benton-Harris and Gerry Badger

Galerie Claire Burrus, Paris (solo)

Anthony Reynolds Gallery, London (group)

PPOW Gallery, New York (group)

Magazine feature, *Camera Asahi*, Japan, June

Magazine feature, *The Face*, London, August

1990
'Conflict Resolution Through the Arts: Focus on Ireland',
Ward Nasse Gallery, New York (group)

Anthony Reynolds Gallery, London (solo)
Cat. *Paul Graham*, Anthony Reynolds Gallery, London; Esther Schipper, Cologne

National Museum of Film and Photography, Bradford (solo)
Artist's book, *In Umbra Res*, National Museum of Photography Film and Television, Bradford; Cornerhouse Publications, Manchester

XPO, Hamburg (solo)

Magazine feature, *Katalog*, Copenhagen, Spring

ANTHONY REYNOLDS GALLERY

PAUL GRAHAM

AT 5 DERING STREET
9 MARCH - 12 APRIL 1990
TUESDAY - SATURDAY 10-6

AT 37 COWPER STREET
9 MARCH - 12 APRIL 1990
WEDNESDAY - SUNDAY 11-6

PRIVATE VIEW COWPER STREET THURSDAY 8 MARCH 6-8

FULLY ILLUSTRATED CATALOGUE

37 COWPER STREET LONDON EC2A 4AP TELEPHONE 01-253 5575
AND 5 DERING STREET LONDON W1R 9AB FAX 01-253 5621

Selected articles and interviews
1989-90

Kent, Sarah, 'Review', *Time Out*, London, 4 April
Schuck, Peter, *Contemporanea*, Turin, April
Renton, Andrew, *Blitz Magazine*, London, May

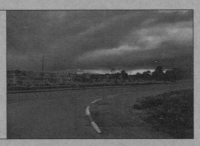

galerie claire burrus

Paul Graham

1990

Kent, Sarah, *Time Out*, London, 1-8 July
Bush, Kate, *Artscribe*, London, No 83, September/October
Reindl, Ute M., 'Paul Graham at Esther Schipper', *Kunstforum*, Cologne, Vol 109, August/October
Currah, Mark, 'Review', *City Limits*, London, 22 March

Hermange, Emmanuel, 'Paul Graham', *Europe 1970–1990*, special issue of *La Recherche Photographique*, No 13, Autumn

Exhibitions and projects
1991-92

1991
'Germany/November 1990',
Aschenbach, Amsterdam (solo)
Cat. *Germany/November 1990*, Aschenbach,
Amsterdam, no text

PPOW Gallery, New York (solo)

'British Photography from the Thatcher Years',
Museum of Modern Art, New York (group)
Cat. *British Photography from the Thatcher Years*,
Museum of Modern Art, New York; Harry Abrahms,
New York, text Susan Kismaric

'The Art of Advocacy',
Aldrich Museum of Contemporary Art, Ridgefield,
Connecticut (group)
Cat. *The Art of Advocacy*, Aldrich Museum of
Contemporary Art, Ridgefield, Connecticut,
text Martha B. Scott

Esther Schipper, Cologne (group)

'The Human Spirit: The Legacy of W. Eugene Smith',
The International Center of Photography, New York
toured to **Centre Georges Pompidou**, Paris; **San Jose
Museum of Art**, San Jose, USA, **Musée de Elysée**,
Lausanne (group)
Cat. Special magazine issue *Camera International*,
No 6, text Robert Pledge

1992
Galerie Claire Burrus, Paris (solo)

'The Billboard Project',
Project and programme commissioned by **BBC TV**,
London (group)

'Whitechapel Open',
Whitechapel Art Gallery, London (group)

Anthony Reynolds Gallery, London (solo)

'Une seconde pensée du paysage',
Domaine de Kerguehennec, Bignan, France (group)

'More than One Photography',
Museum of Modern Art, New York (group)

'Wasteland-Landscape from Now On',
Photography Biennale, Rotterdam (group)
Cat. *Wasteland-Landscape from Now On*, OIO
Publishers, texts Frits Gierstberg and Bas Vroege

'Twelve Stars: Selected Works from the European
Parliament Collection',
Arts Council Gallery, Belfast; **City Arts Centre**, Edin-
burgh; **Barbican Concourse Gallery**, London (group)
Cat. *Twelve Stars: Selected Works from the European
Parliament Collection*, European Parliament, text
Andrew Wheatley

'Vers Une Attitude',
Groupe Caisse des Dépôts et Consignations,
Paris (group)

Arts Council Publications Award

Selected articles and interviews
1991-92

1991

Aletti, Vince, Review, *Village Voice*, New York, 26
February

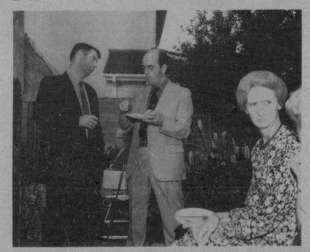

BRITISH PHOTOGRAPHY

FROM THE THATCHER YEARS

Susan Kismaric The Museum of Modern Art, New York

Guha, Tanya, *City Limits*, London, 18-25 June

Une seconde pensée
du paysage

Baqué, Dominique, *Art Press*, Paris, November

Roberts, James, Interview, *Frieze*, London, April

PAUL GRAHAM
NEW WORK

31 JANUARY–23 FEBRUARY 1991
OPENING: THURSDAY JANUARY 31 6–8PM

P•P•O•W 532 BROADWAY, NEW YORK 10012 (212) 941-8642

Exhibitions and projects
1993

1993

Book, *New Europe*, Fotomuseum Winterthur,
Cornerhouse Publications, Manchester

'New Europe',
Fotomuseum Winterthur, Winterthur, toured to **Ikon
Gallery**, Birmingham (solo)
Cat. *New Europe*, Fotomuseum Winterthur, Winterthur,
text Urs Stahel

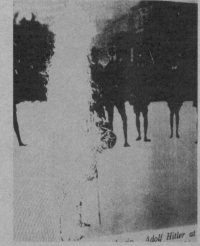

Catalogue cover, *New Europe*, Fotomuseum Winterthur

'On the Edge of Chaos',
Louisiana Museum of Modern Art, Humlebaek,
Denmark (group)
Cat. *On the Edge of Chaos*, Louisiana Museum of Modern
Art, Humlebaek, Denmark, text about Paul Graham,
Tone Nielsen, Anneli Fuchs ed.

'Television Portraits',
Esther Schipper, Cologne (solo)

PPOW Gallery, New York (group)

'Television Portraits',
Anthony Reynolds Gallery, London (solo)

Bob van Orsouw, Zurich (solo)

'European Exercises',
Galerie D-BS, Antwerp, Belgium (group)

'Photographs from the Real World',
Lillehammer Bys Malerisamling, Lillehammer,
Norway, toured to **Museum of Photography**, Odense,
Denmark; **Hasselblad Centre**, Stockholm (group)
Cat. *Photographs from the Real World*,
Lillehammer Bys Malerisamling, Lillehammer, Norway,
text Dag Alveng

Artist's Book, *God in Hell*, Grey Editions, London

Selected articles and interviews
1993

1993

'Eroffnung des Fotomuseum Winterthur', *Neue
Zuercher Zeitung*, Zurich, 30 January
Tschiemer, Elisabeth, *Der Zuercher Oberlander*, Zurich,
29 January
Cerrato, Guiseppe, *Schweizer Ilustrierte*, Zurich,
25 January
'Ein neues Museum, ein neues Europa',
Der Schweizer Beobachter, Zurich, 22 January
Bellini, Catherine, *Le Nouveau Quotidien*, Lausanne,
30 January
Klopmann, Andre, 'L'Europe et les Colonies', *Journal de
Geneve*, 30 January
Deriaz, Francoise, *La Suisse*, Zurich, 31 January
Schaub, Martin, 'Europa, Wunden und Narben', *Tages-
Anzeiger*, Zurich, 1 February
Zwez, Annelise, 'Zeichen der Realitat', *Schaffhauser
Nachrichten*, Schaffhausen, 1 February
'Der Wohlstand und die Not', *Buendner Zeitung*, Chur, 3
February
Oberholzer, Niklaus, 'Ein Neuer Ort fur die Fotografie',
Luzerner Zeitung, 4 February
Goetschel, Edi, 'Der Sturm zum Markt', *Die
Wochenzeitung*, Zurich, 5 February
Maass, Angelika, 'Visuelle Wahrnehmung, Schatten der
Wirklichkeit', *Landboten und Tagblatt von Winterthur
und Umgebung*, Winterthur, 6 February
Grimley, Terry, 'Sombre Visions of a New Europe',
Birmingham Post, 16 August

Feaver, William, 'Under the Influence', *Vogue*, London,
November
Kent, Sarah, 'Paul Graham', *Time Out*, London, 14-24
November

Mack, Gerald, *Das Kunst-Bulletin*, Zurich, No 12,
December
Uccia, Birgid, 'Paul Graham', *Artis*, Bern, December/
January

Exhibitions and projects
1994-95

1994
'Burning Down the House',
Anthony Reynolds Gallery, London (group)

'Television Portraits',
Claire Burrus, Paris (solo)

'Europa 94',
Munich (group)
Cat. *Europa 94 Jungeuropäische kunst in München*,
Europa 94, texts Bernard Wittenbink ed.

'Seeing the Unseen',
Thirty Shepherdess Walk, London (group)

Anthony Reynolds Gallery, London (solo)

'Television Portraits',
Galleri Tommy Lund, Odense, Denmark (solo)

'Project for Europe',
Copenhagen (group)

'Television Portraits',
Raum Aktueller Kunst, Vienna (solo)

Private view card, 'Seeing the Unseen', Thirty Shepherdess
Walk, London

1995
Arts Council Publications Award

Book, *Empty Heaven*, Kunstmuseum Wolfsburg/Scalo
Books, Zurich

'Television Portraits',
Galerie Paul Andriesse, Amsterdam (solo)

Le Case d'Arte, Milan (solo)
Cat. *1995 Catalogue*, Le Case D'Arte, Milan, text Manilo
Brusatin

'Mai de la photo',
Reims, France (group)
Cat. *Mai de la photo*, Ville de Reims, France, text
Béatrice Han

'Witness, Photoworks from the Collection',
Tate Gallery, Liverpool (group)

'Printemps de Cahors',
Cahors, France (group)
Cat. *Printemps de Cahors*, Cahors, France, text Regis
Durand

'Empty Heaven',
Kunstmuseum, Wolfsburg, Germany (solo)

Selected articles and interviews
1994-95

1994

Guha, Tania, 'Paul Graham', *Time Out*, London, 2-9
November
Craddock, Sarah, 'Around Galleries', *The Times*, 14
November
Durden, Mark, 'Paul Graham', *Frieze*, London, No 20,
January/February

Krumpl, Doris, 'Von der Glotze mot Moral', *Der
Standard*, Vienna, 23 December
Hofleitner, Johanna, *Die Presse*, Vienna, 30 December
Hofleitner, Johanna, 'Photographische
Psychogramme', *Die Presse*, Vienna, 19 January 1995
Borchhardt-Birbaumer, Brigitte, 'Assemblage, Blues
und Television', *Wiener Zeitung*, 22 January 1995

Bonaventura, Paul, 'The Man with the Moving Camera',
Artefactum, Antwerp, Vol XI/51, 1 March

1995

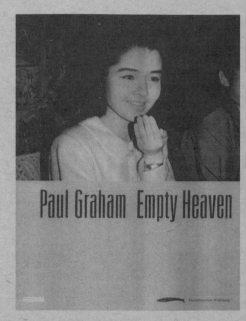

Ollier, Brigitte, 'Paul Graham, un vrai choc', *Libération*,
Paris, 13 May

Karwik, Hans-Adelbert, 'Gesichter Japans von Paul
Graham', *Stadt Wolfsburg*, Wolfsburg, 18 August
'Verstrahlte Haut in Formalin konserviert', *Stadt*

Exhibitions and projects
1995-96

'Esslingen Triennale',
Galerie Der Stadt, Esslingen, Germany (group)
Cat. *Esslingen Triennale*, Galerie Der Stadt, Esslingen,
Germany, texts Ulrich Bischoff and Thomas Weski

Magazine feature, *Portfolio*, No 22, Edinburgh, text
Rebecca Coggins

Charles Pratt Memorial Award, USA

1996
Tate Gallery, London (solo)
Brochure, Tate Gallery, London, text Sean Rainbird

Galleri Tommy Lund, Odense, Denmark (solo)

'Prospect '96',
Schirn Kunsthalle Frankfurt, Kunstverein Frankfurt
(group)
Cat. *Prospect '96*, Schirn Kunsthalle Frankfurt,
Kunstverein Frankfurt, text Peter Weiermair

Anthony Reynolds Gallery, London (solo)

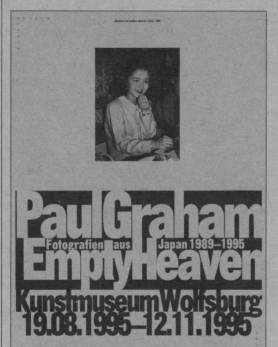

Selected articles and interviews
1995-96

Wolfsburg, Wolfsburg, 18 August
Grosenick, Uta, 'Bubble Wrapped, interview', *Friday
Review, The Guardian*, London, 18 August

1996
Januszczak, Waldemar, 'Tokyo in High Definition', *The
Sunday Times*, London, 5 May
Feaver, William, 'Through the Roof', *The Observer*,
London, 5 May

Aletti, Vince, Review, *The Village Voice*, New York, 26 February 1991

Alveng, Dag, *Photographs from the Real World*, Lillehammer Bys Malerisamling, Lillehammer, Norway, 1993

Badger, Gerry, *Through the Looking Glass: Independent Photography in Britain 1946–1989*, Barbican Art Gallery, London, 1989

Baqué, Dominique, *Art Press*, Paris, November, 1992

Barker, Paul, *Britain in 1984*, The Photographers' Gallery, London, 1984

Bellini, Catherine, *Le Nouveau Quotidien*, Lausanne, 30 January 1993

Benton-Harris, John, *Through the Looking Glass: Independent Photography in Britain 1946–1989*, Barbican Art Gallery, London, 1989

Bishop, William, 'Troubled Land', *British Journal of Photography*, London, 8 May 1987

Bischoff, Ulrich, *Esslingen Triennale*, Galerie Der Stadt, Esslingen, Germany, 1995

Bonaventura, Paul, *Recent Histories*, Hayward Gallery, London, 1987

Bonaventura, Paul, 'The Man with the Moving Camera', *Artefactum*, Vol XI/51, Antwerp, 1 March 1993

Borchhardt-Birbaumer, Brigitte, 'Assemblage, Blues und Television', *Wiener Zeitung*, 22 January 1995

Brusatin, Manilo, *1995 Catalogue*, Le Case D'Arte, Milan, 1995

Bush, Kate, *Artscribe*, No 83, London, September/October 1990

Butler, Susan, *Mysterious Co-incidences*, Photographers' Gallery, London, 1987

Cerrato, Guiseppe, *Schweizer Ilustrierte*, Zurich, 25 January 1993

Coggins, Rebecca, magazine feature, *Portfolio*, No 22, Edinburgh, 1995

Craddock, Sarah, 'Around Galleries', *The Times*, 14 November 1994

Currah, Mark, 'Review', *City Limits*, London, 22 March 1990

Delfgaauw, Leo, *Fotobiennale Enschede 1989*, Enschede, The Netherlands, 1989

Deriaz, Francoise, *La Suisse*, Zurich, 31 January 1993

Durand, Regis, *Printemps de Cahors*, Cahors, France, 1995

Durden, Mark, 'Paul Graham', *Frieze*, No 20, London, January/February 1994

Feaver, William, 'Under the Influence', *Vogue*, London, November 1993

Feaver, William, 'Through the Roof', *The Observer*, London, 5 May 1996

Frisinghelli, Christine, *Konigreich*, special edition of *Camera Austria Magazine*, 1987

Fuchs, Anneli, *On the Edge of Chaos*, Louisiana Museum of Modern Art, Humlebaek, Denmark, 1993

Gierstberg, Frits, *Wasteland-Landscape from Now On*, OIO Publishers, 1992

Goetschel, Edi, 'Der Sturm zum Markt', *Die Wochenzeitung*, Zurich, 5 February 1993

Gossage, John, *Future of Photography*, Corcoran National Gallery of Art, Washington, 1987

Graham, Paul, *A1 – The Great North Road*, Grey Editions, London, 1983

Graham, Paul, *Beyond Caring*, Grey Editions, London, 1986

Graham, Paul, *Troubled Land*, Grey Editions, London, 1987

Graham, Paul, Artist's book, *In Umbra Res*, National Museum of Photography Film and Television, Bradford, Cornerhouse Publications, Manchester, 1990

Graham, Paul, *New Europe*, Fotomuseum Winterthur, Cornerhouse Publications, Manchester, 1993

Graham, Paul, Artist's Book, *God in Hell*, Grey Editions, London, 1993

Graham, Paul, *Empty Heaven*, Kunstmuseum Wolfsburg/Scalo Books, Zurich, 1995

Grimley, Terry, 'Sombre Visions of a New Europe', *Birmingham Post*, 16 August 1993

Grosenick, Uta, 'Bubble Wrapped, interview', *Friday Review*, *The Guardian*, London, 18 August 1995

Grundberg, Andy, 'New Images', *New York Times*, 13 November 1987

Guha, Tanya, *City Limits*, London, 18–25 June 1992

Guha, Tanya, 'Paul Graham', *Time Out*, London, 2-9 November 1994

Han, Béatrice, *Mai de la photo*, Ville de Reims, France, 1995

Handy, Ellen, 'Force of Circumstance', *Art in America*, New York, February 1986

Haworth-Booth, Mark, *Towards a Bigger Picture: British Photography in the 1980s*, special magazine edition, *Aperture*, No 113, New York, Winter 1988

Heller, Martin, *A British View*, Museum für Gestaltung, Zurich, 1988

Hermange, Emmanuel, 'Paul Graham', *Europe 1970–1990*, special issue of *La Recherche Photographique*, No 13, Autumn 1990

Hofleitner, Johanna, *Die Presse*, Vienna, 30 December 1994

Hofleitner, Johanna, 'Photographische Psychogramme', *Die Presse*, Vienna, 19 January 1995

Holborn, Mark, cover and review, *Creative Camera*, London, April 1983

Hoptman, Laura J., *Hot Spots Curator's Choice IV*, Bronx Museum of the Arts, New York, 1989

Januszczak, Waldemar, 'Tokyo in High Definition', *The Sunday Times*, London, 5 May 1996

Jeffrey, Ian, *Ten 8*, Birmingham, No 14, 1983

Karwik, Hans-Adelbert, 'Gesichter Japans von Paul Graham', *Stadt Wolfsburg*, Wolfsburg, 18 August 1995

Kent, Sarah, 'Review', *Time Out*, London, 4 April 1989

Kent, Sarah, *Time Out*, London, 1–8 July 1990

Kent, Sarah, 'Paul Graham', *Time Out*, London, 14–24 November 1993

Kismaric, Susan, *British Photography from the Thatcher Years*, Museum of Modern Art, New York; Harry Abrahms, New York, 1991

Klopmann, Andre, 'L'Europe et les Colonies', *Journal de Geneve*, 30 January 1993

Krumpl, Doris, 'Von der Glotze mot Moral', *Der Standard*, Vienna, 23 December 1994

Lothian, Murdoch, 'Small Signs of Civil War', *The Guardian*, London, 28 March 1987

Maass, Angelika, 'Visuelle Wahrnehmung, Schatten der Wirklichkeit', *Landboten und Tagblatt von Winterthur und Umgebung*, Winterthur, 6 February 1993

Mack, Gerald, *Das Kunst-Bulletin*, Zurich, No 12, December 1993

McGonagle, Declan, Brochure, *Attitudes to Ireland*, Orchard Gallery, Derry, Northern Ireland, 1987

Mellor, David, *The Art of Photography 1839–1989*, Museum of Fine Arts, Houston, 1989

Morgan, Stuart, *Mysterious Co-incidences*, The Photographers' Gallery, London, 1987

Nielsen, Tone, *On the Edge of Chaos*, Louisiana Museum of Modern Art, Humlebaek, Denmark, 1993

Oberholzer, Niklaus, 'Ein Neuer Ort fur die Fotografie', *Luzerner Zeitung*, 4 February 1993

Ollier, Brigitte, 'Paul Graham, un vrai choc', *Libération*, Paris, 13 May 1995

Paley, Maureen, 'Paul Graham', *British Journal of Photography*, London, August 1979

Pledge, Robert, Special magazine issue *Camera International*, No 6, 1991

Rainbird, Sean, Brochure, Tate Gallery, London, 1996

Reindl, Ute M, 'Paul Graham at Esther Schipper', *Kunstforum*, Vol 109, Cologne, August/October 1990

Renton, Andrew, *Blitz Magazine*, London, May 1989

Roberts, James, Interview, *Frieze*, London, April 1992

Rogers, Brett, *Inscriptions and Inventions: British Photography in the 1980s*, British Council, 1987

Saltz, Jerry, 'Notes on a Photograph', *Arts Magazine*, New York, January 1989

Sans, Jerome, Brochure, *Corporate Identities*, Cornerhouse Gallery, Manchester, 1987

Schaub, Martin, 'Europa, Wunden und Narben', *Tages-Anzeiger*, Zurich, 1 February 1993

Schuck, Peter, *Contemporanea*, Turin, April 1989

Scott, Martha B., *The Art of Advocacy*, Aldrich Museum of Contemporary Art, Ridgefield, Connecticut, 1991

Sendon, Manuel, *Third Fotobienal*, Centro de Estudias Fotográficos, Vigo, Spain, 1988

Stahel, Urs, *New Europe*, Fotomuseum Winterthur, Winterthur, 1993

Taylor, Brandon, *Critical Realism*, Castle Museum, Nottingham, 1987

Tschiemer, Elisabeth, *Der Zuercher Oberlander*, Zurich, 29 January 1993

Turner, Peter, Interview with Paul Graham, *Creative Camera*, London, February 1986

Uccia, Birgid, 'Paul Graham', *Artis*, Bern, December/January 1993

Verchaval, Georges, *Troisieme Triennale*, Musée de la Photographie, Belgium, 1987

Vroege, Bas, *Wasteland Landscape from Now On*, OIO Publishers, 1992

Weiermair, Peter, *Prospect '96*, Shirn Kunsthalle Frankfurt, Kunstverein Frankfurt, 1996

Weski, Thomas, *Esslingen Triennale*, Galerie Der Stadt, Esslingen, Germany, 1995

Wheatley, Andrew, *Twelve Stars Selected Works from the European Parliament Collection*, European Parliament, 1992

Wittenbink, Bernard, *Europa 94 Jungeuropäishce kunst in München*, Europa 94, 1994

Zwez, Annelise, 'Zeichen der Realitat', *Schaffhauser Nachrichten*, Schaffhausen, 1 February 1993

Paul Graham
EMPTY HEAVEN
Fotografien aus Japan 1989 - 1995